Monet

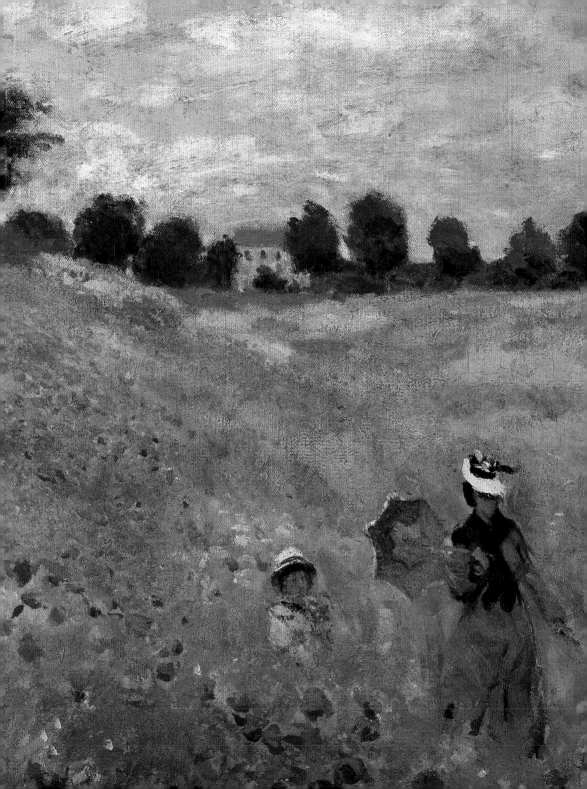

Masters of Art

Monet

Simona Bartolena

PRESTEL

Munich · London · New York

Front cover: *Water Lilies*, 1916–1919, Musée Marmottan, Paris (detail),
Frontispiece: *Poppies at Argenteuil*, 1873, Musée d'Orsay, Paris (detail), see p. 67
Back cover: *Poppies at Argenteuil*, 1873, Musée d'Orsay, Paris (detail), see p. 67

© Prestel Verlag, Munich · London · New York, 2011. Reprint 2016
© Mondadori Electa SpA, 2007 (Italian edition)

British Library Cataloguing-in Publication Data: a catalogue record for this book is
available from the British Library; Deutsche Nationalbibliothek holds a record of this
publication in the Deutsche Nationalbibliografie; detailed bibliographical data can be
found under: http://dnb.d-nb.de

The Library of Congress Number: 2011930378

Prestel Verlag, Munich
A member of Verlagsgruppe Random House GmbH

Prestel Verlag
Neumarkter Strasse 28
81673 Munich
Tel. +49(0)89 4136 0
fax +49(0)89 4136 2335
www.prestel.de

Prestel Publishing Ltd.
14–17 Wells Street
London W1T 3PD
Tel. +44 (0)20 7323-5004
Fax +44 (0)20 7323-0271

Prestel Publishing
900 Broadway, Suite 603
New York, NY 10003
Tel. +1 (212) 995-2720
Fax +1 (212) 995-2733

www.prestel.com

Prestel books are available worldwide. Please contact your nearest bookseller or
one of the above addresses for information concerning your local distributor.

Editorial direction by Claudia Stäuble, assisted by Franziska Stegmann
Translated from the German by Paul Aston
Copyedited by Chris Murray
Production: Astrid Wedemeyer
Typesetting: Andrea Mogwitz, Munich
Cover: Sofarobotnik, Augsburg & Munich
Printing and binding: Elcograf S.p.A., Verona, Italy

FSC
www.fsc.org
MIX
Paper from
responsible sources
FSC® C018290

Verlagsgruppe Random House FSC® N001967
The FSC®-certified paper *Respecta Satin* is produced
by Burgo Group Spa, Italy.

ISBN 978-3-7913-4619-9

Contents

Introduction

The thought of Monet generally elicits a smile—and not without reason, for we immediately think of his Impressionist pictures glowing with light, color, and *joie de vivre*. It was a paintings by Monet that lent its name to one of the most famous and popular movements in art—an "impression" of sunrise over the harbor of Le Havre in north-western France, the moment when the warmth of the sun begins to dispel the morning mist.

We have Monet to thank for the pleasure of radiant pictures in which brightly dressed girls under parasols stroll in flowering gardens, slender trees tremble in the wind, and crowds flow gaily along the broad boulevards of Paris—sunny, out-door paintings that abandoned the art of the fusty studios of the art academies and embraced everyday life ... paintings that still have an extraordinary power to recall happy times. Who would not be glad to sit on a sunlit terrace beside the sea, with the flags fluttering in the breeze and steamboats and yachts passing on the horizon? Who would not want to be present at a picnic in a lush green meadow, the bright, flowing dresses of the girls rustling softly? Or run like a child down a slope speckled with bright red poppies?

Almost effortlessly and without any fanfares, Monet succeeded in diverting painting to a completely new course, shaping a style that may seem superficially "easy"—it's pleasing, raises no problems, is not difficult to copy and imitate, and guarantees long queues at exhibitions and so record takings. But there was another Monet, who is just as important as the sunny painter of the halcyon days of early Impressionism. There was the disappointed and lonely artist who clearly recognized that the days of Impressionism would soon be over. Who, rather against his will, still participated in the ever less satisfying exhibitions of the Impressionist group, left Paris, wandered restlessly through harvested corn fields with their haystacks, walked along the windblown cliffs of Normandy and the misty banks of the Thames, and stood fascinated before the cathedral of Rouen. In his personal life, he had to face a number of severe trials, and was at times marginalized by an art market subject to rapid changes of fashions. At the end, he had scarcely any friends, and in his seventies retreated to his garden in Giverny to live in a private, magical world given over entirely to plants and water. At first sight, this withdrawal seems like flight, as if he wanted to escape current events, as if he were trying to avoid confrontation with the ceaseless succession of styles and artistic movements. But in reality the retreat to Giverny represents one of the most breathtaking and important moments of modern art.

The artist who had played a leading role in bringing together a group of artist friends to form a key movement in modern art, and who, more than any other, was ready to share his experiences, ideas, and methods with his colleagues, was now wholly alone. From his youth, he had always been keenly aware of the wonderful delights of the landscape and the colors of nature. Now his gaze was turned inwards.

He suffered from failing eyesight and lived in isolation from the art world, which was no longer his, cut off from the avant-garde, untouched by the experiments of abstract art. Then Monet discovered a new dimension. Time lost its meaning, space became a closed loop, what he saw of reality was reduced to the gentle dance of water lilies in his garden pond. Impression gave way to contemplation. The paintings of Impressionism had delighted the eye, they were a collective celebration; whereas the excessively painted water lilies were an exercise in the spirit, an intimate and personal affair. We shall always have a deep affection for the youthful Monet of the Paris days, the exuberant, sunny artist of the early years, who was always ready to let in the light of nature and life. But at the same time we should also remember the old artist making his way around the paths of his garden. He walked on the shaky planks of the Japanese bridge and leant on its railings. As Europe suffered the anguish of the First World War and then strove to attain a lasting peace, the old and now taciturn Monet explored the depths of life and of painting in the reflections on the water, in its endless flow, in the ceaselessly dissolving and re-forming patterns of light and color, never ending.

Stefano Zuffi

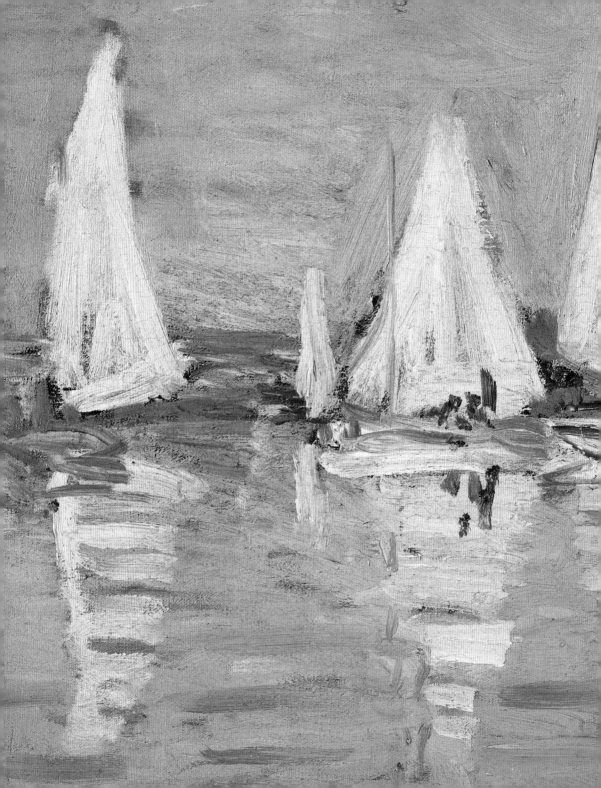

LIFE

The Smile of Impressionism

Oscar-Claude Monet was born in Rue Lafitte in Paris on 14 November 1840, the second son of Claude-Adolphe Monet and his wife Louise-Justine Aubrée. His mother was a musician, but we have no reliable information about his father's occupation; in some sources, he is mentioned as a "property owner." Probably because his father's business affairs were not prospering, the Monet family left Paris for Le Havre on the north-western coast of France in 1845, where his father found employment in the grocery business run by the husband of his half-sister, Marie-Jeanne Gaillard, who had married a Jacques Lecadre; Monet mentions her several times as "Tante Lecadre."

Early years in Le Havre

Monet spent his childhood in Le Havre. Here he trained his eye to observe the scenes that would soon become the subjects of his paintings, ranging from the city's port to the gardens at Sainte-Adresse, where the Lecadre family had a country house.

At school—the municipal college—Monet revealed an early talent for drawing, doing caricatures of those around him with great skill and acute wit. To start with, he did these portraits for his own pleasure, but soon had some commercial success locally. Noticing his extraordinary talent, his mother booked drawing lessons for him with Jacques-François Ochard, a pupil of the celebrated Jacques-Louis David. Monet's "Tante Lecadre" supported this choice of occupation, even in the face of opposition from his father, a sup-

Lady with Parasol, Facing Right, 1886, Musée d'Orsay, Paris

port that continued after the death of Monet's mother in 1857.

But it was not lessons with Ochard that set the young Monet on his life's course, rather his encounter with Eugène Boudin, a painter specializing in maritime subjects. They met through an exhibition of Monet's caricatures in the window of a frame-maker's shop, where seascapes by Boudin were also on show. Boudin was so taken with the quality of drawing that he challenged his younger colleagues to try his hand at painting. After Monet had overcome his initial reluctance, he took Boudin's advice to heart and accompanied his new friend on his open-air expeditions. Working alongside the experienced artist, Monet had what was more or less a revelation: "I watched him attentively," he recalled many years later, "and suddenly it was as if a veil had been lifted. I understood. It had got through to me what painting could be."

The little band of landscape painters

Confident of his own progress, Monet refused to be discouraged when the city of Le Havre turned down his application for a scholarship. His plan to go to Paris was too important to be abandoned, and so he set off with only the modest support of his family and the money he had saved from selling caricatures.

The painter Constant Troyon looked at some of his works and advised him to enroll as a pupil of academic painter Thomas Couture. But the free style Monet had acquired from Boudin would not have met with the approval of Couture, so he went instead to the

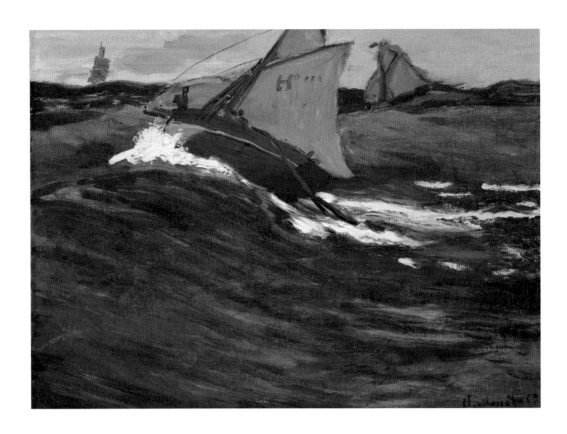

The Green Wave, 1865,
Metropolitan Museum
of Art, New York

Académie Suisse, which was not so much a formal art academy as a place where artists worked together, where teaching materials were available, and where beginners could get to know more experienced artists. At the Académie Suisse—and at the tables of the Brasserie des Martyrs—Monet met various artists who were already successful, including Eugène Delacroix, Charles-François Daubigny, and the then notorious Gustave Courbet, the "father of Realism," as well as leading writers such as Charles Baudelaire and Louis Edmond Duranty.

But Monet's carefree days in Paris were interrupted in 1861 when he was called up for military service. Probably at the prompting of a friend, Monet opted for the 1st Regiment of the Chasseurs d'Afrique, which was stationed in Algeria. He described his military service as a wonderful time. With his eye already schooled to atmosphere, subtle effects of light, and transitory phenomena, military service in North Africa offered him countless new and vivid impressions. He was particularly captivated by the region's intense light and colors, which was a critical experience for his further development.

His stay there was brief, however, for he soon succumbed to typhus and had to be released from the army and sent home. Even as he was recuperating, he had another encounter in Le Havre that proved to be of great importance for

his artistic development. He met Johann Barthold Jongkind and soon struck up a close friendship with him. In an interview in 1900, Monet stressed the role of the Dutch artist in his career: "His work was still too novel ... to be admired at that time, in 1862. He took a look at my sketches, invited me to work with him, and explained the how and the why of his technique, thereby completing the training I had begun with Boudin. From then on, he was my real teacher, and ultimately it is he I have to thank for the final training of my eye."

Back in Paris, Monet continued his formal training in the studio of Charles Gleyre, where he made the acquaintance of Frédéric Bazille, Alfred Sisley, and Pierre-Auguste Renoir. Time and again, he went out to paint in the forest of Fontainebleau together with this "little band of landscape painters," as he himself later called the group. There he put into practice what he had learnt from Boudin, and enthusiastically passed it on to his new friends.

Admittedly, what he learned from Gleyre was wholly different from what his first teacher had taught him. Even though Gleyre allowed his pupils a certain freedom, he remained at heart an academic artist. As Monet recalled: "And so I now set up my easel in the school studio that this famous artist ran. I applied myself very conscientiously during the first weeks, working hard and enthusiastically on my nude from the live model, which Monsieur Gleyre then corrected on Monday. When he came over to me the following week, he sat down and made himself comfortable in my chair to take a close look at my work. I can still see him as he turned round and tilted his dignified head to one side,

and I can still hear him saying with a smile: 'Not bad! That's not at all bad, but it's still too close to the character of the model. It's a rough fellow in front of you, and you paint a rough fellow. He has huge feet, and that's how you paint them. But that's all rather ugly! Mark my words, young man, when you do a figure, you need always to think of antiquity. Nature supplies wonderful objects for study, but nothing of interest comes of them. You see, style is all that matters.'"

Monet chaffed under the rigors of academic painting; if he nonetheless put up with Gleyre, it was only in order not to annoy his father, who felt very little sympathy for his son's artistic career. But it was in vain, since not much later he parted from his family on bad terms, not least because of his relationship with Camille Doncieux, a model who in 1867 gave birth to their first child, Jean.

First essays in open-air painting

With financial support from his father now more inadequate than ever, Monet had to face up to the challenges of "real" life. With the help of his friend Frédéric Bazille, he managed to sell three pictures to collector Alfred Bruyas. But the additional allowances he got from his Aunt Lecadre remained vital; she had been convinced from the first that her nephew's choice of occupation needed to be encouraged.

When Monet first exhibited at the Salon, he at least got a reaction from the press: his painting the *Seine Estuary at Honfleur* was discussed in the *Gazette des Beaux-Arts* and accorded a few complimentary remarks. At this stage, Monet displayed a preference for nov-

elty, notably the Realism of Courbet and the style of Édouard Manet, who was much discussed at the time because of the controversy aroused by two of his paintings, *Déjeuner sur l'Herbe* and *Olympia* (exhibited 1863 and 1865 respectively). Following Manet's example, Monet set about a large-format canvas on the first subject, an open-air luncheon. It was intended as both a tribute to, and personal reinterpretation of, Manet's masterpiece.

Despite the dismissive assessment of Courbet (who incidentally sat for one of the figures), Monet worked with enthusiasm on this ambitious undertaking. Because of a number of unforeseen (largely financial) complications, he was unable to complete the picture in time for the Salon exhibition, and showed instead a portrait of Camille called *Camille in a Green Dress*. This work was also favorably received, and was mentioned approvingly by novelist Émile Zola, a discriminating connoisseur who was to be among Monet's staunchest champions.

A few months later, Monet took up the subject of the Déjeuner again in a painting which, though smaller, was still of considerable size: 2.5 by 2 meters (over 8 by 6.5 ft). The new composition had Camille and another young woman acting as models in a garden. As Monet's first painting done wholly *en plein air*, it was a major turning point in his career. Impressionism emerged soon afterwards, and the pictures Monet painted side-by-side with Renoir in 1869 can clearly be seen as forerunners of the movement. They include the famous series the two artists did at La Grenouillère, a riverside restaurant that was

a favorite destination for day trippers from Paris looking for entertainment.

These were hard years for Monet and his young family. Ever-growing financial difficulties meant that they frequently had to move home, and in the end he had to return to Le Havre alone in order to escape his creditors. At one point, seemingly incapable of coping with the difficulties, the young artist attempted suicide by jumping into the Seine. It was only the support of his close friends, and above all meeting an art collector and businessman called Gaudibert, who commissioned several portraits from him, that enabled him to go on.

The war years

In June 1870, he was finally able to marry Camille, with Courbet as one of the witnesses. The family moved to Trouville in Normandy, where Monet managed to re-establish a degree of emotional equilibrium. But he soon had to flee to England to avoid being called up into the French army, which had just been mobilized after Napoleon III, opposed to a Hohenzollern claim to the Spanish throne, had declared war on Prussia. Completely unprepared, the French were clearly heading for disaster. On 2 September 1870, Napoleon surrendered after a devastating defeat at Sedan. Two days later, the Third Republic was proclaimed.

Prussian troops reached Paris in January 1871 and besieged it. After a period of bitter resistance, the city was finally surrendered to the enemy, who symbolically occupied it for only forty-eight hours. When they withdrew, they left a dramatic situation behind. The

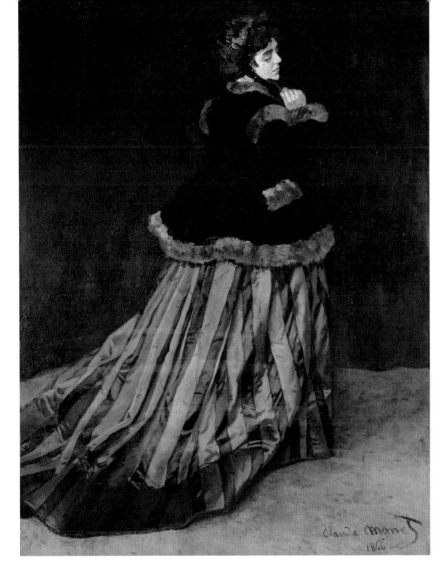

population was still armed for defense, and refused to hand in their weapons. There was an uprising, and the Paris Commune was proclaimed. It was one of the most traumatic periods in French history. The uprising by the Communards was bloodily put down after a week by means of a terrible massacre, the death toll reaching around 20,000. Among the most prominent personalities involved in the activities of the Commune was Courbet, who was charged with inciting the mob to vandalism. Because of his involvement in the uprising, the painter had to go into exile.

News of these bloody events reached Monet in London, where he, Daubigny, and Camille Pissarro painted landscapes, urban scenes,

and views of the River Thames. They also studied masters of the English School. It was while he was in London that two other painful items of news reached Monet—his friend Bazille had been killed on the battlefield at Beaune-la-Rolande on 28 November 1870, and his father had died on 17 January 1871.

Establishment of a limited company

Before he returned to France, Monet spent time in Holland, painting a few seascapes at Zaandam. Subsequently, he stayed only briefly in Paris, moving in January 1872 to Argenteuil, a little town on the banks of the Seine not far from Paris. It would become one of the iconic sites of Impressionism. This was where a very fruitful period in Monet's output began, his style achieving a wholly new character. In Argenteuil, he did some of his incontestable masterpieces—*Poppies at Argenteuil*; *Lunch, Monet's Garden*; *Regatta in Argenteuil*; and *The Railroad Bridge at Argenteuil*, to mention just a few.

But it was also a painting from this period whose contribution to the genesis of Impressionism was unique—*Impression, Sunrise*. His creative zeal and his considerable sales successes (even though it was always the same people who bought his works, namely the art dealer Durand-Ruel, whom he had met during his time in London, and the painter and collector Gustave Caillebotte) encouraged him to return to a project that he had planned with his late-lamented friend Bazille. It was to set up an association of freelance artists that would organize group exhibitions.

The year 1873 was auspicious for Monet. After the upturn in the period following the end of the Franco-Prussian conflict, once again an economic crisis loomed in France. As Monet was very reluctant to lose the modest prosperity he had so laboriously earned, he drove the project forward energetically, talking to countless friends and acquaintances in his search for funding, and on 27 December a limited company was finally established, the Société anonyme des artistes peintres sculpteurs et graveurs. It included artists from a range of different artistic trends, for the shared aim was to offer an alternative to the power of the Academy and of the official Salon exhibition it controlled. The founding document was signed by Monet, Pissarro, Renoir, Sisley, Edgar Degas, Berthe Morisot, Jean-Baptiste Armand Guillaumin, Ludovic-Napoléon Lepic, Jean-Baptiste-Léopold Levert, and Stanislas-Henri Rouart. Numerous newspapers reported the founding of the group. The neutral name was intended to prevent journalists—who had already branded many artists of the group "Les Intransigeants"—talking about a "new school of artists." They became better known as the Impressionists.

From here it was but a short step to organizing the first Impressionist exhibition. The limited company's first show opened on 15 April 1874, a fortnight before the official Salon exhibition. It took place in the former studio of the photographer Nadar, at 35 Boulevard des Capucines.

The public came more out of curiosity than real interest, and the journalists wrote acid reviews. Monet exhibited the already mentioned painting *Impression, Sunrise*, plus a view entitled *Boulevard des Capucines*, which

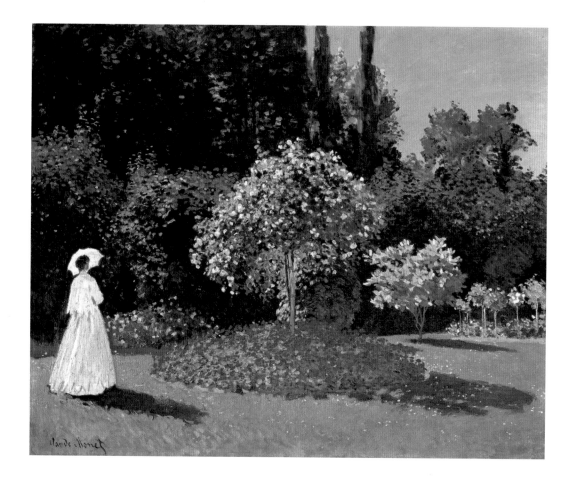

he had painted from the windows of Nadar's former studios (the very place where the first exhibition was held) , and possibly *Poppies at Argenteuil*. The second Impressionist exhibition, which took place at Durand-Ruel's gallery in 1876, was accorded a notably better reception by public and critics alike.

Vétheuil

In the following months, Monet worked mainly in Argenteuil, interrupted by brief stays in Le Havre. He devoted his time to studying complementary colors and developing Impressionist painting techniques so as to capture various effects of light ever more convincingly on canvas. During the summer of 1877, he was for the second time a guest of cultivated art collector Ernest Hoschedé at his château in Montgeron.

Heedless of his ties with Camille, who at the time was pregnant with his second son (Michel, born March 1878), Monet fell in love with his new patron's wife, Alice, and became her lover. In the fall of 1878, after Hoschedé

Woman in the Garden, 1867, Hermitage, St. Petersburg

17

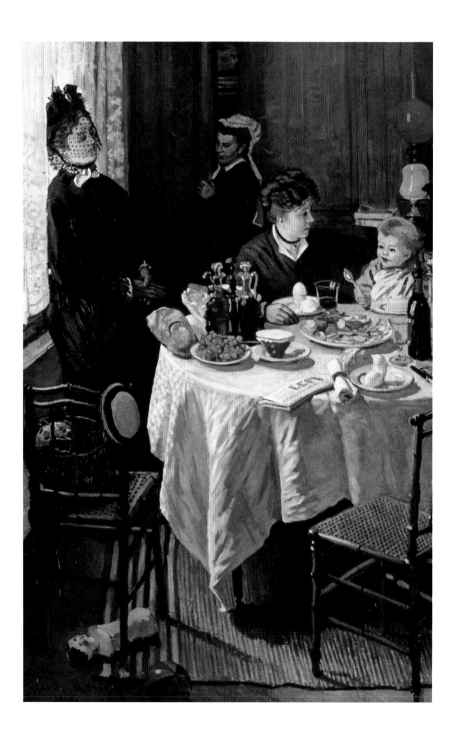

Lunch, 1868,
Städelsches
Kunstinstitut,
Frankfurt

had been declared bankrupt and the Monets had also gotten into financial difficulties, the two families moved to Vétheuil and lived there together, probably in an unconventional *ménage à quatre*. Camille had contracted tuberculosis, and her state of health worsened day by day, until finally she died on 5 September 1879, plunging Monet into a fit of severe depression.

Most of the paintings of these years featured subjects from Vétheuil, which had now replaced Argenteuil in the artist's favor. He painted the little village from all sorts of unusual angles and in very varying weather conditions during the three or more years he and Alice lived there. The painting technique in these pictures anticipates features that would be characteristic of the great series he painted later of haystacks, poplar trees, the façade of Rouen Cathedral, and water lilies.

A sudden thaw in the winter of 1879–1880 had disastrous consequences for the villagers on the banks of the Seine. Ice floes drifted down river causing extensive damage—but also creating spectacular backdrops. Monet made full use of this unique opportunity, particularly as he had always had a preference for landscapes featuring water or snow. We might perhaps interpret the series on melting ice, with its sad, melancholy mood, as biographical, as an expression of the pain he felt at the death of his wife. They are an almost unique exception in the work of a painter who otherwise, even in very difficult periods of his life, typically painted serene landscapes flooded with sunlight.

In 1880, Monet began to turn away from the Impressionist group. His friend Renoir had already anticipated the move, and had not exhibited with them the previous year. Perhaps in the hope of re-establishing himself financially, Monet now decided to participate in the official Salon exhibition again. But the reception he got there was not exactly what he had hoped for. The only picture accepted was *Lavacourt*, and even that was so hung so high that it could hardly be seen.

But at the same time, Monet resumed contact with the art dealer Durand-Ruel, who purchased numerous paintings, improving the artist's financial situation sufficiently for him to be able to set off for northern France again. In Normandy, Monet painted a series of pictures in Fécamp depicting breaking surf, a subject he returned to several times, for example in 1883 and 1885, when he painted the cliffs of Étretat, and again in 1886, during his stay on Belle-Île, an island off the coast of Brittany.

With Les Intransigeants again

In order to rectify his complex family relationship, in 1881 Monet made his connection with Alice Hoschedé public, after having lived with her for some time in Vétheuil. He, Alice, and their respective children then moved to Poissy. Monet now painted in Dieppe, Pourville, Petites-Dalles, and Varengeville in a quest for inspiration. Particularly in Varengeville, with its little church on the cliffs, he created landscapes of quite a new character, works characterized by experimental coloration. Not in a position to grasp the novelty of these pictures, the critics presumed the painter had possibly gone colorblind, and passed harsh judgments on them.

Yet the response to Monet's first solo exhibition, at Durand-Ruel's gallery in 1883, was thoroughly positive. The year before, Monet had shown his works at, among other places, the seventh (and penultimate) group exhibition of the Impressionists. Relationships between members of the group were not running smoothly. "I've just been visited by an abrasive Pissarro, who told me about your next exhibition," reported Manet in a letter to his sister-in-law, the artist Berthe Morisot: "The gentlemen do not seem to be on particularly good terms. Gauguin is playing the despot, Sisley, whom I've also just seen, would like to know what Monet will do. And Renoir isn't back in Paris yet."

That the exhibition did nonetheless take place was due mainly to the intervention of Durand-Ruel, who for understandable reasons worried about the future of the artists, whom he represented almost exclusively. So the dealer wrote to Monet and Renoir urging them to take part in the exhibition.

Among the conditions that Monet set for his participation, it is particularly notable that he insisted his faithful friends Caillebotte and Renoir should also exhibit. Renoir was still undecided whether he should take part or not; he was annoyed by the way the preparations had gone and by the fact that he had not been invited to the previous exhibitions. He was also worried that contact with the "revolutionaries," the "Intransigeants," could endanger his hard-earned position as a Salon artist. The skepticism of both artists was aggravated by the participation of a number of Pissarro's protégés, namely Guillaumin, Paul Gauguin, and Victor Vignon.

Yet regardless of these unfavorable conditions, and the absence of Degas, the seventh exhibition of the group represented the high point of Impressionism. Writing to the collector Georges de Bellio, Pissarro commented: "Monet exhibited a group of great works, wonderful seascapes, landscapes with a completely new look, and executed with that unsurpassable technique." Monet showed thirty paintings.

Traveling

Looking for a new, possibly permanent place to live, Monet finally discovered Giverny, a village on the Seine 80 kilometers (50 miles) from Paris. Fascinated by the special atmosphere of the place, he decided to settle there and to move into a small country house with his family. Thus there began a serene and highly creative period of his life, marred only by the sad news of the death of Manet on 30 April 1883. For Monet, Giverny was a little paradise that offered countless attractive subjects to paint. But he did not want to tie himself down yet, and after just a few months set off again, hungry for new sources of inspiration.

He visited Renoir in Rouen, and set off with him on a brief trip to the Ligurian Riviera in Italy and the Cote d'Azur in France, where he met Paul Cézanne. Monet was deeply impressed by the colors and light on the Italian coast ("often I'm positively overwhelmed by all the shades of colors I'd have to paint," he wrote to Alice). So he decided to return alone at the beginning of the following year in order to try again to capture the impressive landscapes on canvas.

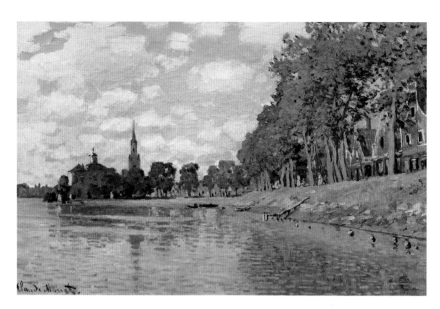

In Bordighera in Italy he worked on nearly fifty paintings, many of them left unfinished. And now, even though Durand-Ruel (whose apartment, incidentally, he decorated with floral motifs) remained his most important dealer, Monet began to establish contacts with a competitor, Georges Petit. The artist was skeptical about his first dealer's idea of opening a gallery overseas; with his unusual perspicacity, Durand-Ruel, whose businesses in Europe were not doing too well, had perceived the market potential of the United States. And he was not wrong: liberal purchases by American collectors would prove to be the foundation of the financial success of the Impressionists. Although Monet refused to agree to Pissarro's proposal to organize another group exhibition ("Couldn't we come to an agreement there?" Pissarro pleaded), he continued to take part in the monthly supper at the Café Riche, which the leading representatives of the group usually attended.

Monet's unwillingness to take part in the eighth group exhibition was probably due to the involvement of Georges Seurat and Paul Signac. Pissarro had discovered these progressive young artists, who submitted stylistically highly original works using a technique that would later be called Pointillism. The great experimenter Monet, the feared revolutionary, the most convinced of "Les Intransigeants," seems to have been no longer in a position to respond to the ideas of a younger generation. Instead, he received an invitation from Georges Petit to take part in a current international exhibition at his gallery.

Painter of the impossible

After a brief trip to Holland, Monet once again turned to the coast of northern France for new inspiration, painting in Port-Goulphar, Port-Domois, and Port-Coton. He remained there for some time, observing with fascination how the sea surged and ebbed over the rocks and

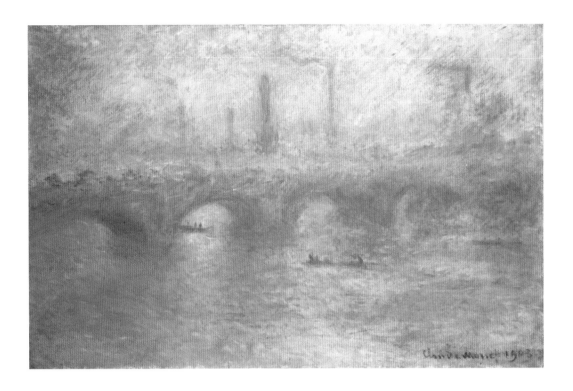

Waterloo Bridge, 1903, Hermitage, St. Petersburg

beaches, how the waves broke on the cliffs, and trying again and again to record such scenes, even in appalling weather.

His works were now increasingly receiving positive reviews from some of the most important critics, including Octave Mirbeau and Gustave Geffroy, through whom he got to know Georges Clemenceau, editor-in-chief of the periodical *La Justice*, with whom he struck up a lifelong friendship. In one of his many articles about Monet, Geffroy describes Monet's house in Giverny, where the artist had assembled a small but impressive collection of modern art. Along with important paintings by Boudin, Delacroix, Jongkind, Manet, Pissarro, Renoir, Signac, Sisley, Camille Corot, Henri Fantin-Latour, and Édouard Vuillard, there was also a fine selection of Japanese prints.

Even Van Gogh's brother, Theo, was interested in Monet, and enabled him to exhibit at the Royal Society of British Artists in London, via the Galerie Boussod, for whom Theo then worked. When Monet traveled to England for this, he stayed with James McNeill Whistler, and also met John Singer Sargent, who was held in high regard, especially for his striking portraits.

On his return to France, Monet tried his hand at a number of figure paintings—a genre to which he had previously paid little attention. As with the landscapes, here too his interest focused on rendering reality in all its changeability, as it is actually perceived by the eye. Monet was trying more and more determinedly to capture "the impossible," as he himself called it.

And this is when he began painting in series, an approach that dominated his late work. The subject of a painting now became merely a pretext for painting. It was no longer a question of whether he was painting of a common haystack or the majestic façade of a cathedral. What mattered was the perception of these objects and the rapid changes in their appearance as a result of the atmospheric conditions at any given moment.

The logic of a series became indispensible; it was the only thing that he could employ to maintain the courageous battle against passing time. The same subject was shown at different times of the day and in different weather conditions, so as to record on canvas the subtle, sometimes scarcely perceptible changes in nature. Reality was now that which exists only in the eyes of the observer who has abandoned the notion of supposed objectivity in favor of the very modern notion of the subjectivity of all perception.

In 1888, Monet stayed in Antibes in the south of France, where he once again sought the light and colors of the Mediterranean landscape of the Cote d'Azur. He wanted to explore the "delicacy of white, pink and blue" in what was then still a quiet little town on the coast. It was no easy matter. He was aware that he had to fight the same battle repeatedly: "I seem to have to begin all over again every day, without getting anywhere," he wrote to Alice, and continued: "I'm afraid of finishing it and of being empty." Theo van Gogh did not share this view, and bought on the spot ten views of Antibes to show in a solo exhibition in Paris. Among those who went to see it were the writers Guy de Maupassant, the Symbol-ist poet Stéphane Mallarmé, and Prince Eugene of Sweden. In early 1889, Georges Petit organized another important exhibition, at which Monet met the celebrated sculptor Auguste Rodin.

Along with his successes in exhibitions, in the first months of the following year Monet realized a personal ambition. After months of trying, he succeeding in acquiring Manet's masterpiece *Olympia*, and presented it to the Louvre as a gift. Monet had called on a great many acquaintances and contacts to prevent Manet's picture being bought by an American collector and so taken out of the country, writing hundreds of letters so as to collect the required number of supporters. It was a task to which he devoted himself with touching single-mindedness and determination. That was his way of paying his respects to an extraordinary painter whom he had always valued as an inspiration.

The same year, Monet was also able to fulfill a long-held dream: to buy the house he had been renting in Giverny, together with the surrounding land, where he could lay out a garden that included a water-lily pond. With Alice (whom he had married in 1891, after her first husband died) and their children, he now finally settled in Giverny, where he would spend the rest of his life.

At this date, Monet had already begun to work on series of paintings wholly devoted to a single motif. The first of these series, the *Haystacks*, met with sharply divided reactions from critics. There was harsh, mocking criticism from those who saw just a boring repetition of one and the same—moreover rather uninteresting—motif in these pictures. Oth-

ers, who grasped the modernity of these experiments, applauded his artistic achievements enthusiastically.

After the death of Theo van Gogh, who had been unable to overcome his grief at the suicide of his brother Vincent, the aging Durand-Ruel once again played a more prominent role in Monet's professional career. He was always ready to find room for Monet's pictures, and was particularly fascinated by the *Haystack* series, to which he devoted an entire exhibition.

In 1892, Monet rented a room in Rouen overlooking the cathedral. This building became the subject of a series of pictures that he revised constantly over the next two years. The Gothic façade of the cathedral was an ideal subject for the studies in perception that Monet had begun with his *Haystack* series. He felt that the paintings he did in Rouen could be appreciated only as a complete series, and so when he assembled them all at Durand-Ruel's gallery in Paris he instructed the dealer not to sell any of the pictures individually, insisting on the unity of the series.

In 1894, some of Monet's works passed into state ownership as a result of a legacy by his prematurely deceased friend Caillebotte.

The following year, Monet set off on his travels again, this time to Norway, where he visited the area around Christiania (now Oslo). He was welcomed with open arms by young Norwegian artists who already regarded him as an inspiration and teacher. He painted the icy landscapes around Kolsås Mountain and the snow-covered cabins of Sandviken, a village in the vicinity of the capital. After his Nor-

wegian excursion, Monet returned to Paris to open his new exhibition at Durand-Ruel. It was divided into three main sections, each dedicated to a single motif: Rouen Cathedral, the town of Vernon, and the area around Christiania.

The pictures exhibited met with conflicting reactions. Some critics expressed reservations and were particularly dismissive of the Rouen Cathedral series, in which his apparently "unfinished" painting technique and his experimental handling of color were more pronounced. Particularly supportive, however, was Georges Clemenceau, who would later be a champion of the great water-lily series in the Orangerie. After the Panama Scandal (1892), in which he was personally involved, Clemenceau had retired from politics in order to devote himself entirely to journalism. On 20 May 1895, he published an article in *La Justice* called "The Revolution of the Cathedrals," in which he wrote: "This is what bold Monet has now undertaken in his twenty paintings of Rouen Cathedral, which break down into four series I would call as follows: the Grey series, White series, Rainbow series, and Blue series. With these twenty paintings, each with its own well-considered effect, the painter gives us the impression that he could have painted fifty, a hundred, a thousand pictures, ultimately as many as his life has seconds, should he live as long as the monument in stone … As long as the sun shines on it, there will be as many appearances of Rouen Cathedral as the units of time into which man is in a position to divide time. The perfect eye would be capable of distinguishing them all, since they are united in the vibrations that can

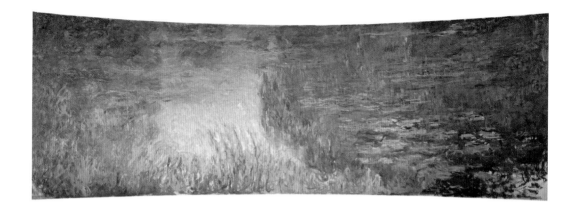

be taken in by our present-day retina. Monet's eye goes on ahead of us, leading us in the Academy of Seeing that makes our perception of the world more penetrating and subtle."

International successes

In 1897, for an article in *Revue Illustré* magazine, the journalist Maurice Guillemot spent a day observing Monet at work. The result was a vivid account of the artist's working methods. These were the years when Monet devoted himself to getting to grips with a single motif, such as a scene on the banks of the Seine or his water-lily pond. But by this time he was also achieving increasing success with the public and art critics. And it was no longer just a small coterie of interested parties competing for his pictures—mainly Durand-Ruel and Petit. Other gallery owners, art dealers, and foreign collectors now also came. For Impressionism, and therefore Monet as well, who even at that time was considered the chief representative of the movement, it was the start of a successful period. He had by now also acquired a sound international reputation, his paintings being shown in Boston, New York, Dresden, and Moscow.

Yet professional success alternated with difficult moments in his private life; above all, he had to cope with the deaths of fellow artist Alfred Sisley and his own stepdaughter, Suzanne Hoschedé. In addition, there were the first problems with his eyesight, which worsened from year to year.

Between 1899 and 1901, Monet made several visits to London, where he concentrated on a motif that had preoccupied him in his younger years there—the Thames Embankment. Working from the windows of his room at the Savoy Hotel, he painted Charing Cross railroad bridge—a more mature English variant of the French railroad bridges he had painted as a young man—Waterloo Bridge, and the Houses of Parliament. In 1901, during a longer spell in London, Monet also painted evocative and innovative nocturnal views of Leicester Square.

Monet conceived the paintings he did in London as a systematic series, and therefore he refused to show works singly, regarding them as inseparable parts of a whole. Even his dealer Durand-Ruel, who was keen to organize an exhibition of the London works, had to wait until after the painter had returned before he got to see the first paintings.

Water Lilies, Morning, 1914–1926, Musée de l'Orangerie, Paris

Meantime, back in Paris, the 1900 World Fair had opened. In the showrooms of this huge event, which embraced a wide diversity of areas in industry, art, and design, the works of Monet, who was already considered the uncontested "father of Impressionism," occupied a prominent position. Monet's participation in the World Fair brought him new fame and even more public attention. In 1903, the owner of the Bernheim-Jeune gallery, for example, used the opportunity to put on an exhibition of works by Monet and his friend Pissarro, not long before Pissarro died. The following year, Durand-Ruel, wanting to consolidate his own role in Monet's career, organized an unsurpassed exhibition of Monet works, including, finally, the London pictures. The celebrated gallery owner also ensured that an Impressionist exhibition was put on in London as well. Once again, Monet was the chief representative of the group there, and with few exceptions the paintings exhibited by him were extraordinarily successful.

In 1908, Monet traveled to Venice. For him, the Serene Republic was Impressionism in stone, a city made for his brush. Under the loving eyes of Alice, who was happy to see him so active—while at the same time worrying greatly about his health, as emerges from her letters of the time—Monet painted a series of views of the Lagoon.

During the following years, Monet constantly returned to pictures he had begun in Venice, reworking and changing them, which did not always produce satisfactory results: "All I'm capable of at present," he wrote in 1911, "is completely ruining numerous pictures from Venice. I shall have to destroy them—that is the sad result of my labors. I would have done better to have left them as they were, as a reminder of happy days spent with my dear Alice."

A water garden

The works painted in Venice went largely to the Bernheim-Jeune gallery, his new dealers; but for Durand-Ruel, Monet had a much more important project in mind: the water-lily series.

Monet worked on this series of paintings of the water-lily pond almost secretly, in the seclusion of his garden in Giverny. It would become his most famous and most experimental series. At the exhibition on the gallery premises of the now elderly art dealer, forty-eight variations on the subject were exhibited under the title *Les Nymphéas: series de paysages d'eau* (Water Lilies: A Series of Water Views).

"Not so much the traditional garden of a flower lover as that of a colorist," is how Marcel Proust described the garden that Monet had laid out in Giverny. "The flowers are, if you like, arranged into an entity that is no longer that of nature. ... It is a veritable transposition of art, less a subject for a painting than a painting already implemented in nature itself, that lights up under the eyes of a great painter."

This garden, the final refuge of the aging painter, would become virtually his only subject in the last phase of his artistic career. It was a studio in the open air, created with much patience and passion by an artist who was also a discerning connoisseur of plants and flowers and a skilled gardener. There was a

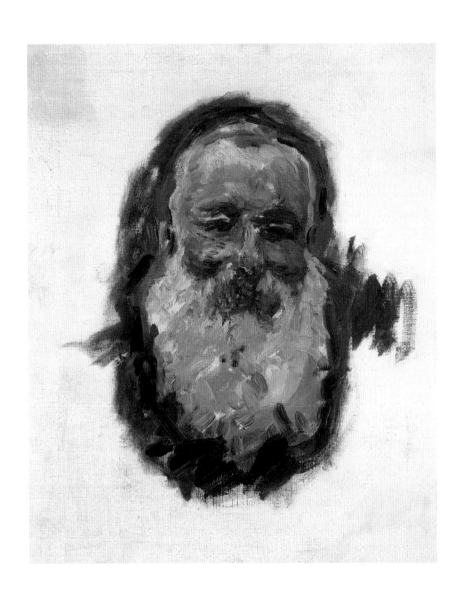

Self-Portrait, 1917,
Musée d'Orsay, Paris

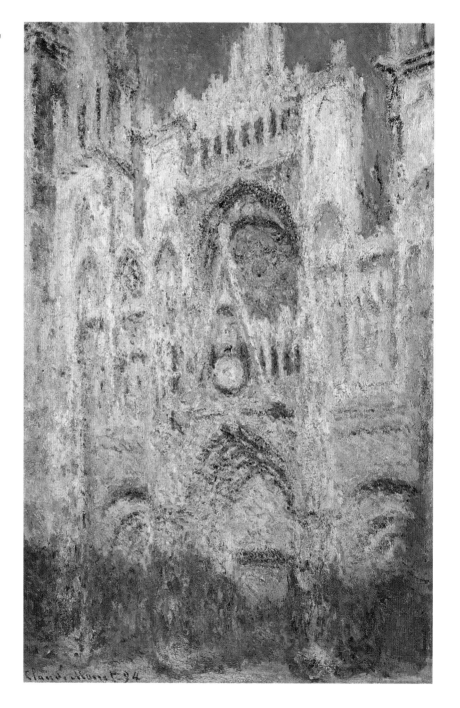

firm principle in his garden in Giverny: every single flower was chosen for its color, scent, and shape so as to create an original "living work of art" with the other species.

The exhibition was controversial. Monet had reached such a high level of abstraction that he attracted the interest of those who supported the avant-garde's new forms of expression. "Those who write articles about my painting come to the conclusion I have reached the ultimate degree of abstraction and imagination in combination with reality," Monet observed. "I would prefer them to recognize the gift it involves, complete self-abandonment."

Monet was now alone. Alice had died in May 1911, followed three years later by his eldest son, Jean. Blanche, his stepdaughter and at the same time daughter-in-law (she had married Jean), supported Monet, but otherwise painting was all that was left to him. On Clemenceau's advice, he set up a large studio where he could work on paintings of monumental dimensions—the water-lily pictures now exhibited at the Orangerie. The project rekindled his appetite for work. As countless times before, and despite having to cope with his steadily deteriorating sight, Monet set himself a huge challenge. He deployed all his mental and physical powers in order to complete the work before his eyesight finally failed.

The new studio was completed in 1915. Europe was at war, and nothing around him was the same any more. He seemed to take no notice. In the seclusion of his botanical paradise, he carried on his ceaseless struggle with the nature of perception and the mutability of reality. He attempted to ignore the political situation and even the tempestuous innovations and revolutions of the artistic avant-garde. The younger generation of artists, however, whose work had long since left Impressionist experiments behind, were still fascinated by this old painter, this "little man of 84 years," as Maurice Denis described him in his journal, who had gone almost completely blind and yet his "color tones are more exact and true than ever."

The great series of water-lily pictures, which had originally been intended for the garden pavilion of what later became the Musée Rodin, finally ended up (after protracted dispute) in a room of their own at the Orangerie in the Tuileries. Monet himself took charge of the alterations to the premises where the paintings were to be shown. Everything was ready, but the aging painter obviously had difficulties in parting with his final creations.

By this time almost completely blind, and more and more alone—Renoir had died in 1919, and his friend and confidant Gustave Geffroy in 1926—Monet finally decided to have an eye operation. This partly restored his sight, and he was able once again to devote himself to his work and to looking after his beloved garden.

On 25 June 1926, he consulted a specialist. In a letter by his stepdaughter, Blanche, there is mention of an eye tumor; in the fall, an attempt was made to limit its spread. It was his old friend Georges Clemenceau who stood by him to the end and took care of his final wishes and dispositions. Claude Monet died on 5 December 1926.

WORKS

Spring Flowers

1864

Oil on canvas, 116 x 90.5 cm
Museum of Art, Cleveland

Spring Flowers is one of the earliest of Monet's well-known paintings, and also one of his most perfect and interesting still lifes. At the time, still life was a very popular genre, attracting the interest of painters of such stature as Gustave Courbet and Édouard Manet, who was of the view that still lifes were the real test of an artist's skill and technical abilities. The young Monet, who was still on a quest for subjects that would make his name, seems to have shared this view. It meant reinterpreting the genre, starting from traditional models in a realistic vein and developing new forms of still life. Convinced of the quality of this painting, Monet submitted it to an exhibition in Rouen, but, according to his own account, it was hung so badly that no one could see it properly.

Undoubtedly, the flower still lifes by Eugène Boudin and by Courbet (particularly the splendid flower vase painted in 1862, now in the J. Paul Getty Museum in Los Angeles) were important models for the young painter, but the very personal and innovative character of this painting cannot be overlooked. A comparison with contemporary paintings by Auguste Renoir and Frédéric Bazille is instructive. The stylistic affinity between these works makes it clear that the three young artists were all searching for new forms of expression, driven by the same delight in experiment.

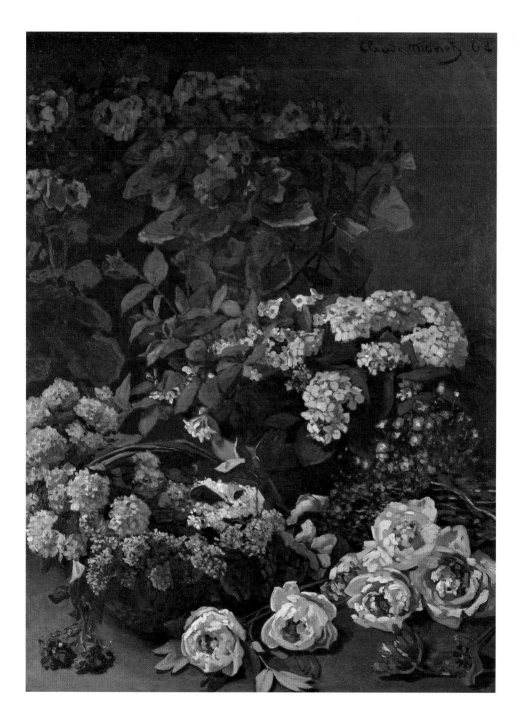

The Bodmer Oak in the Forest of Fontainebleau

1865

Oil on canvas, 97 x 130 cm
Metropolitan Museum of Art, New York

The tree that the young Monet depicted in this painting, which stood in the forest of Fontaine-bleau near Paris, was named after Swiss artist Karl Bodmer, who had exhibited a painting of this huge oak, which was a favorite with both painters and photographers, at the Salon of 1850.

The Forest of Fontainebleau is one of the seminal locations of modern landscape painting. It was beneath the boughs of this extensive "green lung" in the hinterland of Paris that the painters of the Barbizon School—a group of landscape painters that included Camille Corot, Charles Daubigny, François Millet, and Théodore Rousseau—met to paint in the open air. They were undoubtedly artists whose approach had a vital influence on the genesis of Impressionism. From April 1865 onwards, Monet and his friends Frédéric Bazille, Auguste Renoir, and Alfred Sisley, fellow students from the studio of Charles Gleyre, went out together to Chailly-en-Bière to spend whole days painting in the Forest of Fontainebleau. Not surprisingly, the paintings of these years, as in this depiction of an old oak, clearly shows the influence of the Barbizon School.

This painting is one of a series of three studies for a large-format composition intended for the Salon. The lively realism with which Monet rendered the forest suggests the influence of Gustave Courbet; Monet obviously wanted to combine the style of the great Realist with the open-air experiments of the Barbizon School. At the same time, the quick brushstrokes and the close attention he devoted to the play of light and shade, in particular the dappled sunlight breaking through the foliage, already anticipate features of his later work—a stylistic code that would soon make its breakthrough in his ambitious *Déjeuner sur l'Herbe*.

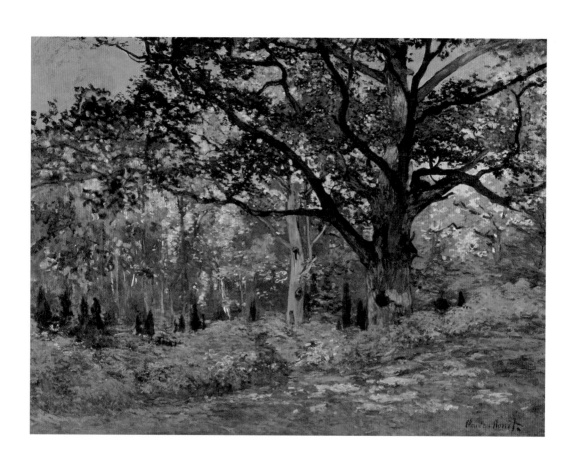

Déjeuner sur l'Herbe

1865–1866

Oil on canvas, 418 x 150 cm; 248 x 217 cm
Musée d'Orsay, Paris

These two fragments now preserved at the Musée d'Orsay in Paris are all that survives of a monumental painting (around 4 by 6 meters/13 by 19 ft.) that Monet began in Chailly-en-Bière during the summer of 1865. In 1866, he stopped work on the unfinished painting in order to work full-time on *Camille in a Green Dress* (see page 15), a full-length figure painting of his model Camille, the woman who would later become his wife, which he wanted to submit to the Salon that year. By way of preparation, Monet did sketches in the open air, but the painting itself he executed in the traditional way in the studio—the monumental dimensions of the canvas ruled out open-air painting.

In great financial difficulties, Monet had to leave the unfinished painting with his landlord in lieu of rent, who stored it in a cellar. Years later, Monet got the painting back and rescued three fragments. The rest he had to throw away. One of these fragments later vanished.

A number of studies have survived, including one of the overall composition that is now in the Pushkin Museum in Moscow. The latter is particularly important for understanding the complexity of the figure composition on which he had embarked.

As the title indicates, the picture is unmistakably a tribute to Édouard Manet, who had caused uproar with his controversial *Déjeuner sur l'Herbe* at the Salon des Refusés in 1863. Monet shows a group of figures who have made themselves comfortable beneath the foliage of a tree. Friends of the artist, including Frédéric Bazille and Camille, sat for the painter. The bearded man in the centre of the composition could be Gustave Courbet, the uncontested master of Realism, whose work the young Monet had taken as one of his models. The location of the scene is also of great symbolic importance—the Forest of Fontainebleau, where the painters of the Barbizon School, the founding fathers of modern landscape painting, had met to work.

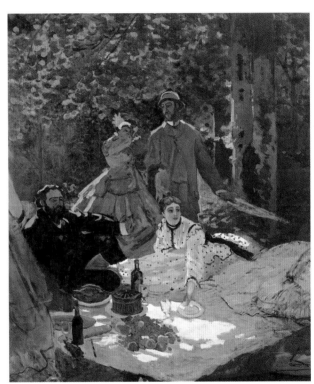

Garden in Sainte-Adresse

1867

Oil on canvas, 65 x 54 cm
Musée d'Orsay, Paris

In a letter written in June 1867, Monet reports to his friend Frédéric Bazille that he had begun a series of "amazing seascapes, figurative pictures, and garden scenes." He was undoubtedly referring to a number of pictures he painted in Sainte-Adresse, where he was staying with his aunt, Marie-Jeanne. Along with the painting at the Musée d'Orsay, this group of works also includes two famous paintings: *Terrace at Sainte-Adresse* of 1867 (see page 43) and *Jeanne-Marguerite Lecadre in the Garden* (1867, Hermitage, St. Petersburg). Émile Zola, who appreciated the innovative aspect of Monet's paintings, was deeply impressed by these works. He said that Monet had "created a series of paintings with garden views. I know of no pictures imbued with such personal tone or such a characteristic eye. The flowerbeds studded with the red of the geraniums and the matt-white of the chrysanthemums stand out against the yellow sand of the paths. There are rows of suspended flower baskets with strollers admiring them, coming and going in light, elegant clothes. I would be glad to see one of these pictures at the Salon; but the jury appears to be there in order studiously to refuse them entry."

In this splendid version now in the Musée d'Orsay in Paris, Monet gives free rein to the direct, uninhibited application of paint, enabling the viewer to get a vivid impression of a flowering garden on a sunny day. Short, quick brushstrokes suggest the materiality of the petals, the vibrant intensity of the blue sky, and the sequence of blended green tones used to depict the lawn and plants.

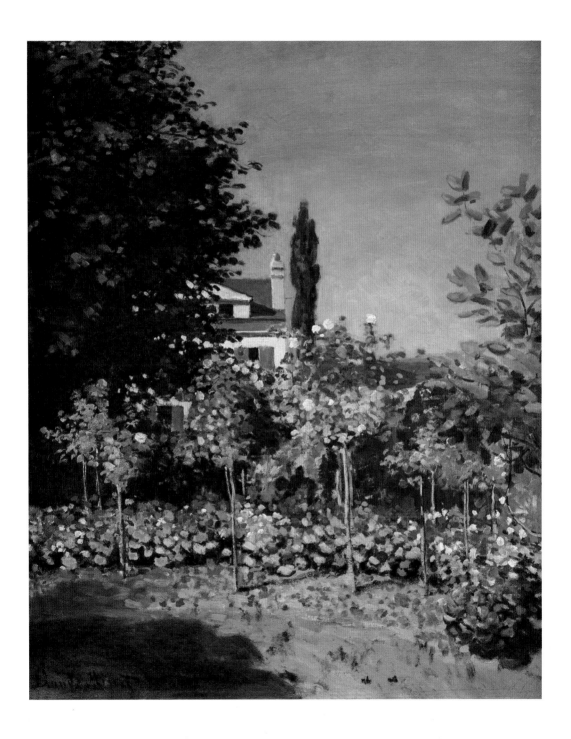

Women in the Garden

1866–1867

*Oil on canvas, 255 x 205 cm
Musée d'Orsay, Paris*

Encouraged by the success that the portrait of his model (later wife) Camille had had at the 1866 Salon—a success that had made him very optimistic with regard to his future artistic career—Monet turned his attention again to a scene of figures in a landscape of the kind he had begun with his monumental *Déjeuner sur l'Herbe* (see page 37). After the difficulties he had faced when painting this huge painting, which remained unfinished, Monet now went for a smaller format, particularly as he intended to paint the picture entirely in the open air. Even though the work is noticeably smaller than the previous one, the dimensions are still considerable (2.5 by 2 meters/over 8 by 6.5 ft.), which made handling it outdoors difficult. The dimensions were particularly ambitious given the everyday subject—Monet obviously wanted to challenge the canons of academic painting, which specified that formats of this kind were reserved for more serious and conventional subjects, not scenes of everyday life. Not surprisingly, *Women in the Garden* was rejected by the jury of the Salon, who had smiled so benevolently on the portrait of Camille.

The picture marked an important point in the stylistic development of the artist. After it, there was no turning back. It thus counts as one of the key works in the genesis of what became later Impressionist painting.

Camille was the model for three of the four female figures, which clearly suggests that this representation of women in different poses was ultimately little more than an artistic pretext for rendering the effects of light and shadow on fabrics and on the ground. Indeed, Monet has here already captured with astonishing skill the patterns of dappled sunlight filtering through the foliage of the shrubs to create sharp accents of brightness. Apart from a few uncertainties than can be ascribed to the painter's youth, the painting displays considerable mastery in the handling of color.

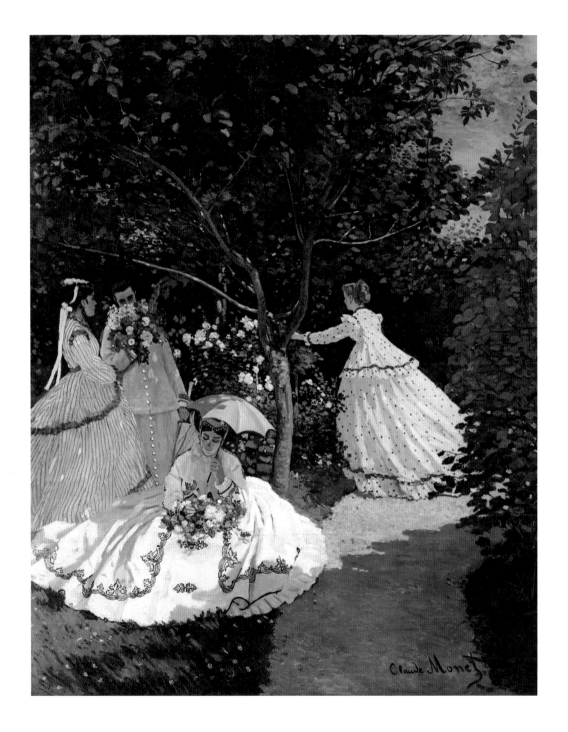

Terrace at Sainte-Adresse

1867

Oil on canvas, 98 x 130 cm
Metropolitan Museum of Art, New York

In a letter to his friend Frédéric Bazille in 1868, Monet refers to this painting as a "Chinese picture with flags." The term Chinese—which at this date was used synonymously with Japanese—is of crucial importance if we wish to understand what the artist was aiming at with this scene from the seaside resort of Sainte-Adresse near Le Havre on the Normandy coast. He obviously wanted to paint a scene in a Far Eastern style. Monet collected Japanese prints, and here he could have been especially inspired by one that he possibly already owned—the *Pavilion of Sazai in the Temple of the 500 Rakan*, which shows a group of figures on a terrace beside the sea, a woodcut (now preserved in the Musée Claude Monet in Giverny) from a series of thirty-six views of Mount Fuji by Hokusai.

Monet took ideas from Japanese art not just directly from Japanese originals but also indirectly from artists who had already responded to *japonisme* by adopting Japanese elements—first and foremost, Édouard Manet. Monet delighted above all in the linearity and stylizations of Japanese prints, which encouraged him to construct compositions using flat, monochrome fields of color.

His models for this painting were Dr. Alphonse Lecadre and his daughter Jeanne-Marguerite; she had already featured in a fine portrait of her in a garden he painted the same year (Hermitage, St. Petersburg). The real protagonist, however, is the atmosphere of a scene bathed in bright light, with a fresh breeze making the flags flutter without disturbing the serene tranquility of the moment.

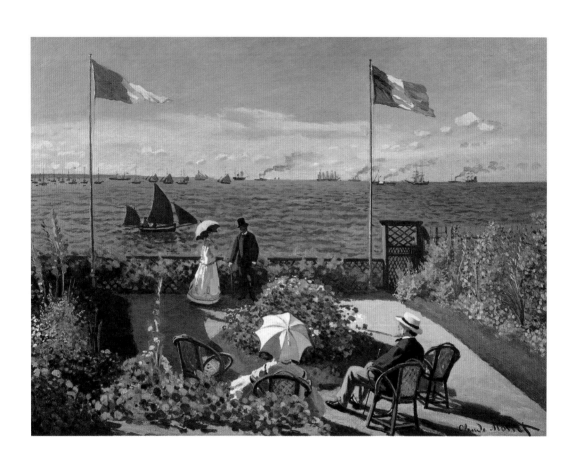

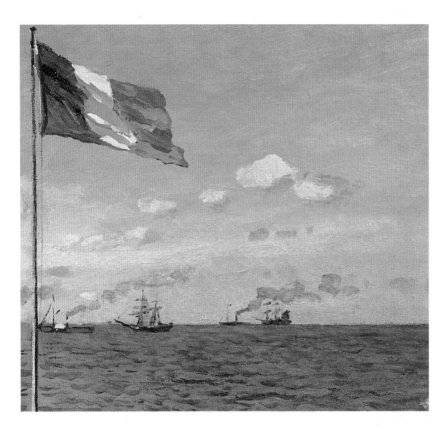

Terrace at
Sainte-Adresse
(details)

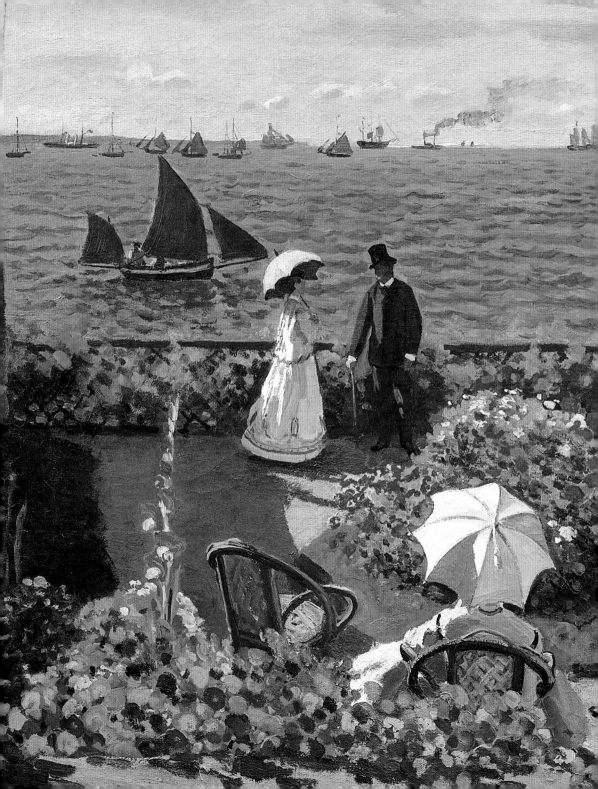

Madame Gaudibert

1868

Oil on canvas, 216 x 138 cm
Musée d'Orsay, Paris

Madame Gaudibert's attention has obviously been caught by something out of view. At any rate, she seems to pay not the slightest attention to the presence of the artist painting her portrait, nor to the viewer regarding her likeness.

Monsieur Gaudibert, a prosperous Le Havre businessman, commissioned three portraits from Monet, two of himself (both now lost) and one of his wife, Marguerite, so as to help Monet out of his financial difficulties. Marguerite was only twenty-four at the time, an elegant young middle-class woman, as her well-cut clothes and dynamic but cool pose indicate. Borrowing from a previous portrait, *Camille in a Green Dress* of 1866 (see page 15), with which he had had such success at the Salon, Monet shows Madame Gaudibert full-length and in slightly averted three-quarters profile.

The earlier picture was somewhat more accessible thanks to the movement with which Camille turns to look over her shoulder at the viewer, and to the extraordinary volume of the dress displayed in all its stripy fullness in the foreground. Even though Monet goes to great lengths here to do justice to the prevailing taste, with an emphatically bourgeois portrait, he cannot resist following his own instincts. The composition is unusual, and the paint is applied with free, impetuous brushstrokes. The picture is more akin to examples from Édouard Manet's oeuvre, such as the *Street Singer* (1862, Museum of Fine Arts, Boston) or the *Lady with Parrot* (1866, Metropolitan Museum of Art, New York), than the sophisticated portraits by the society painter Carolus Duran. Though he was first and foremost a landscape artist, Monet can also be considered a highly innovative portraitist who was endeavoring to escape the fashionable conformity of portraiture in his day.

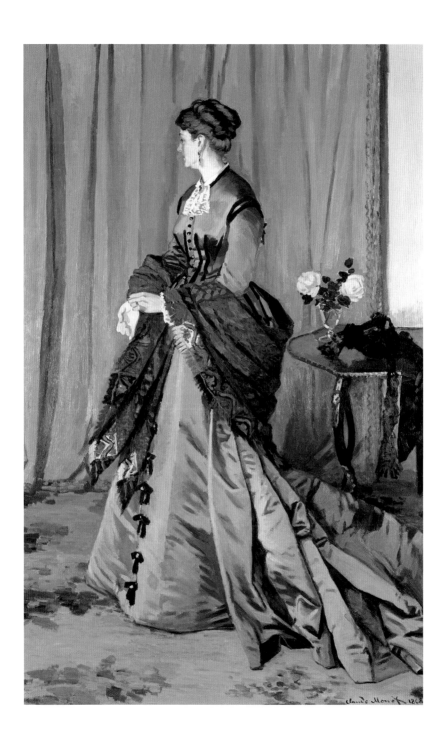

La Grenouillère

1869

Oil on canvas, 75 x 100 cm
Metropolitan Museum of Art, New York

Set on a branch of the Seine near Croissy, not far from Paris, La Grenouillère was a restaurant with bathing facilities that was particularly popular with trippers from the capital on the hunt for distraction or some relative peace and quiet in the country. Monet and Auguste Renoir came here in 1869 to paint side-by-side, each recording the lively, smart and yet rustic scene in his own distinctive way. Both artists managed to capture its special atmosphere in their paintings, the clamor and people moving on the jetty, the rustling of clothes, and the shimmering reflections of light on the surface of the water.

Unlike Renoir, who was more interested in the figures, Monet went for the wider angle and focused more on the landscape. It was above all water that fascinated him. It is rendered with astonishing immediacy, solely by means of small, horizontal brushstrokes that, seen from the right distance, capture very precisely the idly rippling waters of this branch of the Seine.

The days he spent with Renoir painting in the open air away from the city persuaded the young Monet that open-air painting was the right way for him. Even though they are works from his youth, these scenes taken from real life, in which he managed to capture the look of a fleeting moment with a few brushstrokes, contain basically all the elements of Impressionist painting.

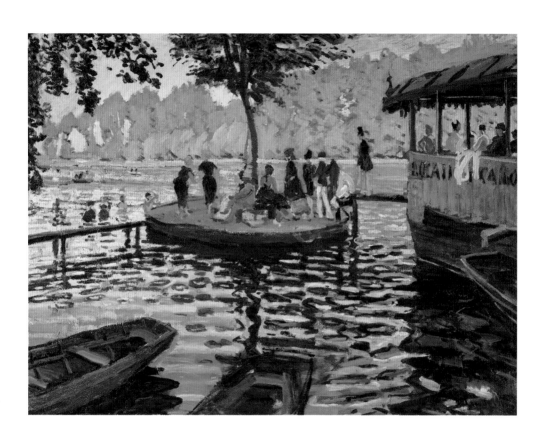

La Grenouillère
(details)

The Magpie

1869

Oil on canvas, 89 x 130 cm
Musée d'Orsay, Paris

Not much is known about this painting, which Monet probably painted in the winter of
1868–1869. It is undoubtedly one of his most enchanting works. Monet deploys sundry tones
of white side-by-side with absolute assurance in a subtle interplay of delicate nuances.
Impressionism was just at the beginning of its development, and was not even aware of
itself, and yet Monet was already master of the grammar of this artistic language,
instinctively knew how to use it, and already displayed the painterly quality of the style that
would make history.

The picture is a good example of Monet's capacity to paint snow, a motif that was popular
with Impressionists. What made this element so interesting to Monet and other
Impressionists was its permanently changing surface and the difficulty of recording on
canvas its particular shimmer and subtly reflected colors. "There is no white in nature,"
Auguste Renoir would later write: "I'm sure you will agree that above the snow there's the
sky. The sky is blue. This blue must appear on the snow." This painting seems to be Monet's
implementation of his friend's perceptive observation. With rapid brushstrokes he builds up
an infinite variety of white tones, blending them up with violet, ochre, and blue, and
displaying in the process an incredible sensitivity in the handling of color and light.

The painting was rejected by the jury of the 1869 Salon, and it is not difficult to see why—the
format is too large for a landscape, the color application is too free and relaxed, and the
execution not detailed enough. Monet was not discouraged by the rejection. Fully
determined, he continued along the path he had chosen. A few years later, he would bring
the Impressionist movement into existence.

The Magpie (details)

The Thames and Houses of Parliament (Westminster Bridge)

1871

Oil on canvas, 47 x 72.5 cm
National Gallery, London

In 1870, Napoleon III declared war on Prussia, launching the conflict between France and Prussia that would end in the occupation of Paris by Prussian troops. Among the few artists who decided to remain in the city were Édouard Manet and Edgar Degas. Monet on the other hand went to London, where other landscape painters had already gone, including his friends Camille Pissarro and Alfred Sisley. In England, Monet was primarily in contact with Pissarro and Charles Daubigny (of the Barbizon School), but he mainly used his time there to get to know the works of the great English masters, from Thomas Gainsborough to John Constable and J.M.W. Turner.

How great the influence these artists may have had on the young French artists is disputed in the literature, but one may certainly say that in London Monet took a final great step in painting open-air landscapes, since his city views, above all of the Thames Embankment, incontestably convey a great fascination with the British capital. When Monet returned to London years later, he characteristically resumed the threads of his earlier works and painted the same locations again, only this time in a more mature idiom (see page 123). For this view of the Thames Embankment and Houses of Parliament and Westminster Bridge, Monet chose a palette of light, shimmering, opalescent tones against which the dark vertical lines of the piers and filigree silhouettes of the figures stand out in *contrejour*. In the background, the outlines of the Houses of Parliament loom quietly skywards, half-veiled by the mist shrouding the whole scene.

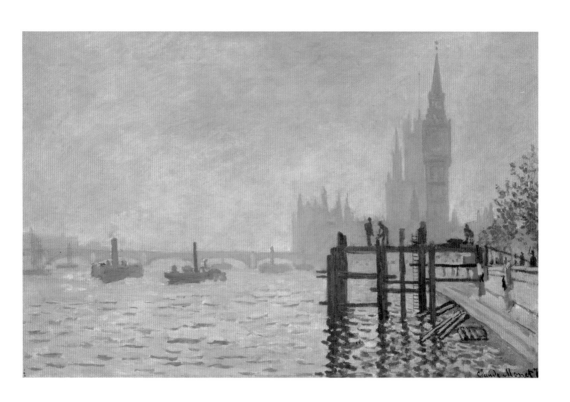

Regatta at Argenteuil

1872

Oil on canvas, 48 x 75 cm
Musée d'Orsay, Paris

Monet was deeply shocked when news reached him in 1871 that his friend Frédéric Bazille had been fatally wounded the year before in the Franco-Prussian War, on the battlefield of Beaune-la-Rolande, and he decided to return to Argenteuil. As the little town was well-placed on the railroad network, and so easily accessible from Paris, it developed into a favorite location for the Impressionists. The following year, Monet rented a house there, and in 1874 retreated to Argenteuil with several of the painter friends who had taken part in the first Impressionist exhibition. In his studies of scenes along the Seine, he repeatedly returned to the subject of regattas, a motif that allowed him to concentrate on capturing the ever-changing reflections on the surface of water.

Monet divided the composition horizontally into upper and lower halves, producing a dialogue between the "reality" above and the reflections below. The brushstrokes are almost playful in their rendering of both—the tangibly real and the fleeting reflections. The unmixed paints are applied with flat strokes placed side-by-side rapidly and summarily. His choice of colors is highly interesting and decidedly innovative. Recent investigations have shown that twelve of the twenty most important colors in the Impressionist palette were synthetic pigments: lemon yellow (barium chromate), chrome yellow, chrome red, emerald green, cerulean, and others. This can be observed very well in this painting: apart from the reds, he used only synthetic colors, almost always unmixed, in a sophisticated interplay of complementary colors—blue/orange, red/green, yellow/violet.

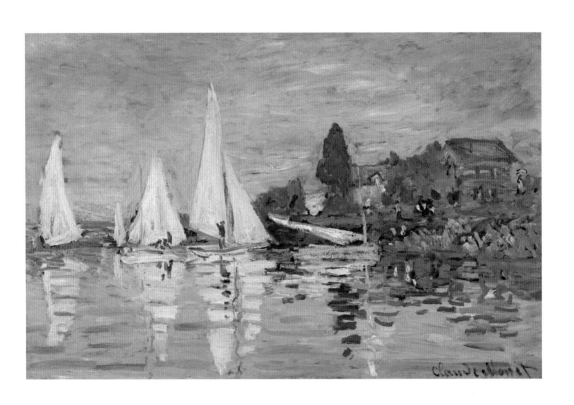

The Basin at Argenteuil

1872

Oil on canvas, 60 x 80.5 cm
Musée d'Orsay, Paris

In an essay written in 1878, the critic Théodore Duret was one of the first to note that Monet was "a painter of water par excellence." He continued: "In old landscape painting, water appears in a motionless and monotonous guise, with its 'water' color, a surface on which objects are simply reflected. In Monet's paintings, water no longer has its own unvaried color; it takes on an infinite variety of appearances according to the conditions of the atmosphere, the type of bed over which it flows, or the silt it carries along. It can be clear, cloudy, tranquil, turbulent, fast flowing or idly, depending on the temporary conditions observed by the artist as he sets his easel before its liquid surface."

Édouard Manet, who incidentally shared this assessment, was so impressed by Monet's representation of water that he was not averse to describing his friend as the "Raphael of water." In this picture, Monet depicts the peaceful tranquility of the broad branch of the Seine at Argenteuil with assured but unconstrained strokes. He knows how to capture the agreeable relaxation of a late afternoon in this entrancing rural location. Here, too, Monet creates a scene of extraordinary vitality. Every detail, from the clothes of the tiny walking figures to the white sails of the boats on the river, appears to be on the move, seeming to vibrate in the sun and wind.

Impression, Sunrise

1872

Oil on canvas, 48 x 63 cm
Musée Marmottan, Paris

It was probably this painting—although there is a second very similar version now in a private collection—that the critic Louis Leroy sharply criticized in the periodical *Le Charivari* on 25 April 1874, and that ultimately gave its name to the group of artists later so famous as the Impressionists. Leroy was obviously not capable of grasping the innovations and originality that distinguished this group of young artists, who were exhibiting their works in the former studio of photographer Nadar on the Boulevard des Capucines in Paris: "Impression—certainly. And I thought, if it makes an impression on me, there must be an impression in it ... and what freedom, what lightness of technique! Wallpaper in its unprinted state is more finished that this seascape!"

The painting is a view of the port of Le Havre, familiar to Monet from his childhood. The silhouettes of the ships and quaysides stand out like ghosts in the morning mist. Monet sketched them in with dark, rapidly placed brushstrokes that break up in the vibrant orange of the sky and are reflected in the water. *Impression, Sunrise* is perhaps not among Monet's best works, but it is exemplary of the "unfinished" quality of his painting technique, an open-air style that focuses on the momentary impression of reality not its fixed details— which is why it was rejected by critics and the academic establishment.

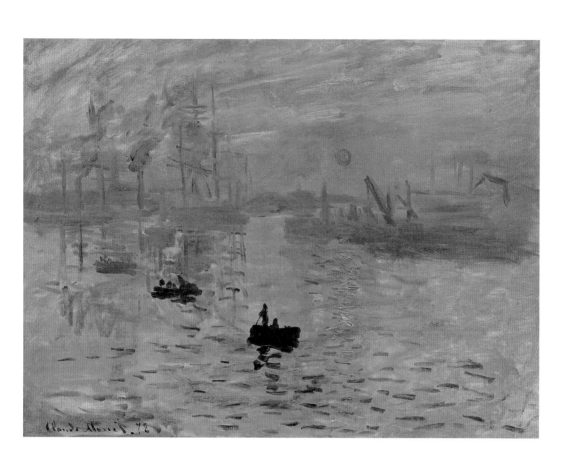

Poppies at Argenteuil

1873

*Oil on canvas, 50 x 65 cm
Musée d'Orsay, Paris*

This scene of a landscape near Argenteuil, which was probably shown at the first Impressio-
nist exhibition in 1874, is one of the best-known works by Monet, and of Impressionism as a
whole. The artist used short red and green brushstrokes to convey the magical atmosphere
of a poppy field in bloom. The horizon, which is sketched in as an irregular avenue of trees,
divides the balanced composition into two approximately equal halves. A bright sky full of
irregular white clouds stretches over the meadow, with its diverse shades of green. As a
counterpoint to the two figures in the foreground—a woman and child—there is a second
pair of figures rather further back. Monet probably again used Camille and their son Jean
as models. But the four figures are there purely for compositional purposes. They break up
the uniformity of the scene, standing out as distinct patches of color against the green of
the trees and the meadow. They also draw the viewer into the picture. The visitors to the
first Impressionist exhibition were not prepared for such works. For a viewer used to
academic paintings, this masterpiece by Monet, with its sketchy, impetuous brushstrokes,
inevitably came across as simply unfinished, as if merely an oil sketch. The copious use of
synthetic paints, often being applied unmixed directly to the canvas, also challenged
conventional taste.

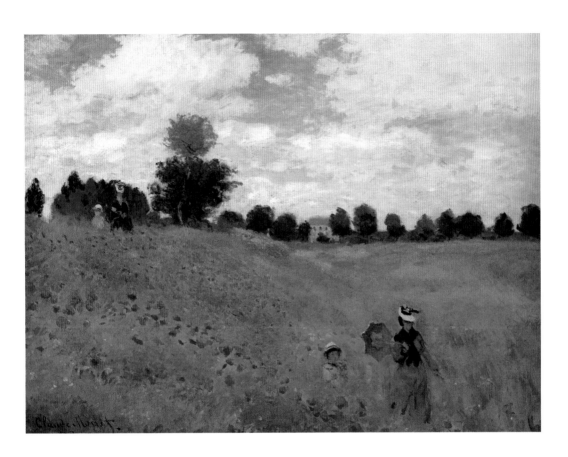

Boulevard des Capucines

1873

Oil on canvas, 80 x 60 cm
Nelson Atkins Museum of Art, Kansas City

Paris "changes faster than the heart of a mortal," wrote the poet Charles Baudelaire. The vitality of this constantly evolving city also provided the Impressionists with numerous subjects. In the second half of the 19th century, Paris had changed radically under Napoleon III, due to the grand urban schemes driven by Seine departmental prefect Baron Haussmann, the city becoming a veritable stage for *la vie modern* (modern life). The most conspicuous features of the new face of the city were the broad boulevards. The mediaeval city had been sacrificed for their sake, the narrow alleys having proved well suited for the erection of barricades, which in the event of a new popular uprising could have proved very dangerous. As new arteries, squares, markets, theaters, and bridges were built, the whole city was provided with street lighting by gas. Paris became the "city of light," the most admired and imitated metropolis in Europe.

Like Nadar, who had photographed the city from a hot-air balloon, Monet also discovered that the streets offered unexpected and fascinating views if seen from unusual angles. For this magnificent painting, it was from the window of Nadar's former studio that Monet viewed the Boulevard des Capucines. It was an ideal vantage point from which to observe the teeming life on the streets. From this distance, the figures have become small, "innumerable, black licking marks," as critic Louis Leroy wrote in his review of the first Impressionist exhibition in 1874. "Is that what I look like when I walk down the Boulevard des Capucines?" he asked in *Le Charivari*. "Heavens above! Are you trying to make a fool of me?"

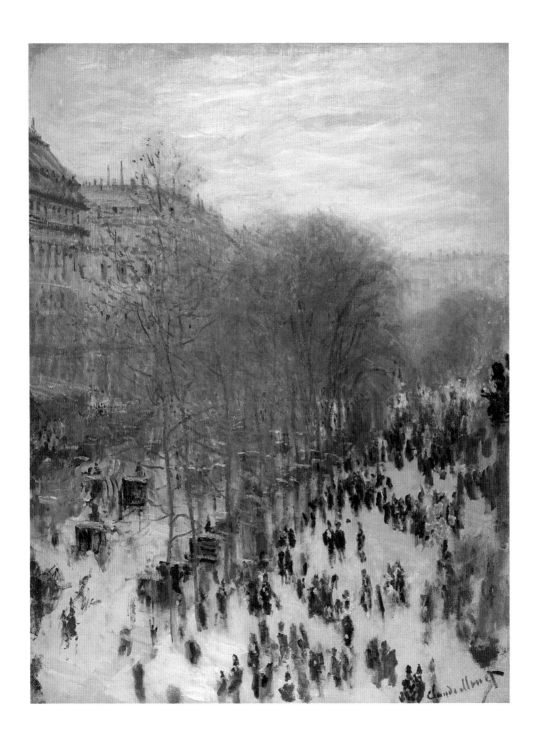

Lunch, Monet's Garden at Argenteuil

1873–1874

Oil on canvas, 160 x 201 cm
Musée d'Orsay, Paris

A family scene in the garden of Monet's house in Argenteuil—a midday meal in the open air.
On the left, beside the small table, we see little Jean, the painter's son, playing with building
bricks, while in the background two women, possibly Camille and a friend, stroll peacefully
round the garden. In the foreground are the remains of lunch—cups, a coffee pot, wine
glasses, bread, fruit …

It is a wonderful still life, enlivened by the interplay of light and shadow casting patterns on
the tabletop and being reflected on the curved surfaces of the glasses and coffee pot. It is
the small details (a flower on the table, the parasol on the bench, and the hat with black
ribbons hanging from the branches of a tree) that contribute to the magical mood of this
scene. As usual, the flowers have been created with just a few quick, deft brushstrokes.
Compared with the early works painted in Sainte-Adresse, here Monet was already
displaying extraordinary assurance of technique. It is open-air painting of the highest
quality.

Now in the Musée d'Orsay collection, the painting was originally owned by Gustave
Caillebotte. He himself was one of the Impressionists, and supported the joint cause to the
best of his abilities, constantly buying pictures from his friends and co-financing the
exhibitions. The generous painter bequeathed his very rich collection of Impressionist
works to the state. His bequest triggered off a lively controversy among artists and
academic, with the result that some of the sixty-seven paintings bequeathed were rejected.
A committee of "experts" was set up whose duty was to give an opinion on the "real artistic
value" of the works in question.

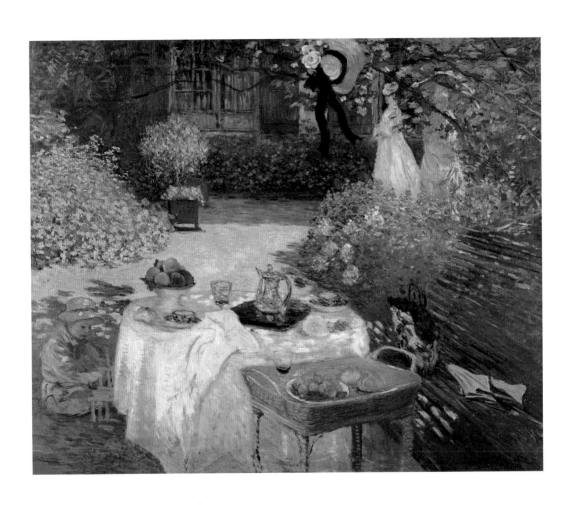

The Railroad Bridge at Argenteuil

1873-1874

Oil on canvas, 55 x 72 cm
Musée d'Orsay, Paris

The railroad reached Argenteuil in 1851. As a consequence, the tranquil little town by the Seine became one of the most popular and most visited destinations for Parisian trippers looking for a day out in the country. The railroad bridge was a subject Monet painted several times during his visits to the area. It was his first encounter with the subject of railroads, and was followed three years later by a series on the Gare Saint-Lazare, the newest station in Paris (see page 83).

Here, the bridge is seen from below, from an angle that makes the massive iron structure seem particularly monumental. The eye of the painter seems to glance only fleetingly towards the dark silhouettes of the train, being much more interested in the contrast between the key natural elements of the scene—the water, the sky, and the wind dispersing the steam from the engine's funnel.

The compositional lines are also very effective. The diagonal of the bridge is echoed by the line of the densely overgrown embankment in the foreground, which in turn contrasts with the horizontal line of the opposite bank, and then with the vertical lines of the massive piers of the bridge.

In the foreground, Monet gives us a sample of his outstanding talent for rendering the surface of water. Using short, rapid, overlapping strokes of unmixed colors he captures perfectly the surface of the slowly flowing current. The soft, irregular shapes of the passing clouds add to the special atmosphere of the landscape—they seem to be in a conversation with the busy ripples of the water and the dense smoke from the engine's funnel.

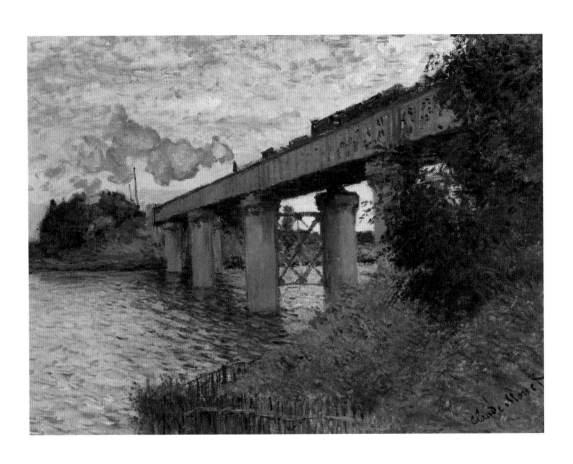

Lady with Parasol and Child

1875

Oil on canvas, 100 x 81 cm
National Gallery of Art, Washington

The subject of figures in a landscape gives rises to special difficulties, for the artist has to bring the two elements into a balanced relationship; but it was a motif explored by the Impressionists again and again. This famous painting shows Monet's wife Camille with their son Jean in the open air on a windy day. But it is not a portrait of two members of a family in a traditional sense: it is one of countless attempts by Monet to explore the possibilities of open-air painting. Blazing sunshine sets the mood, shining from a blue sky and casting long shadows across a strip of ground bright with small flowers. Everything in the scene seems to be in motion, from the scurrying clouds to the trembling blades of grass. To reinforce this dynamism, Monet gets his model Camille to move. She turns towards the painter, her clothes billowing out with her movement and winding themselves round her body as the wind catches them. The angle Monet chooses here—he was always on the lookout for new perspectives—is interesting. Camille and Jean are seen from below, so that the grassy bank covers part of their figures.

Monet returned to the subject in two paintings executed in 1886, which are now in the Musée d'Orsay (see page 11). In these, the model for the woman in white with the green parasol was no longer Camille, who had died in 1879, but Suzanne Hoschedé, the daughter of his second wife. The two new versions of the subject display great similarities with this picture in terms of pose, dress, angle, and mood—particularly in the version with the woman turned towards the left. Obviously Monet consciously returned to the youthful work to update it and, as it were, to bring it to the level of his mature work.

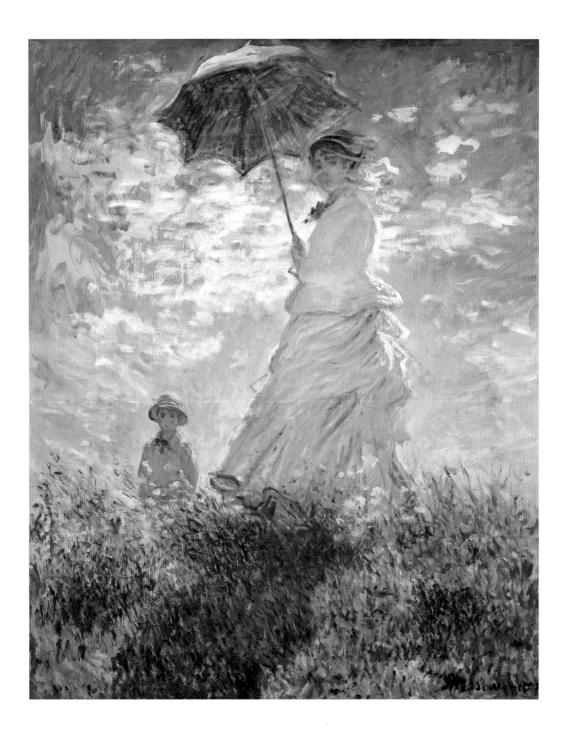

*Lady with Parasol
and Child
(details)*

Madame Monet in Japanese Costume

1876

Oil on canvas, 231 x 142 cm
Museum of Fine Arts, Boston

As a landscape painter, Monet only rarely took the human figure as his subject. This painting is perhaps his most convincing venture into the field of portrait painting. The sitter is his first wife, Camille, who, half in jest, wears the costume of a geisha. Here, with a twinkle in his eye, Monet is alluding to the fashion for *japonisme* in his day. Enthusiasm for the Far East strongly influenced contemporary taste, both in female fashions and in art. In the pavilions of the World Fair in Paris, especially in 1867, the French discovered a fascination for the woodcuts of the great Japanese masters such as Utamaro and Hokusai, who were already well known to, and indeed highly regarded by, most progressive European artists. Monet himself was a passionate collector of Japanese prints, and studied their line, composition, and articulation very closely. Particularly in his later works, their influence is unmistakable, and can also be seen in the design of the bridge over the water-lily pond in Giverny.

In the case of this enchanting portrait, the tone, however, is more ironic, a playful mockery of *japonisme*. Smiling, blonde Camille adopts a saucy, very theatrical pose, while the wonderful embroidery on her gown and the rich palette lend the scene dynamism and opulence. Obviously a pleasant game between a married couple is involved here rather than a serious coming to terms with Japanese aesthetics.

The numerous fans on the wall in the background—which create a strong sense of movement—are an unmistakable reference to the portrait of Nina de Callias (Musée d'Orsay, Paris) that Éduard Manet had painted three years earlier.

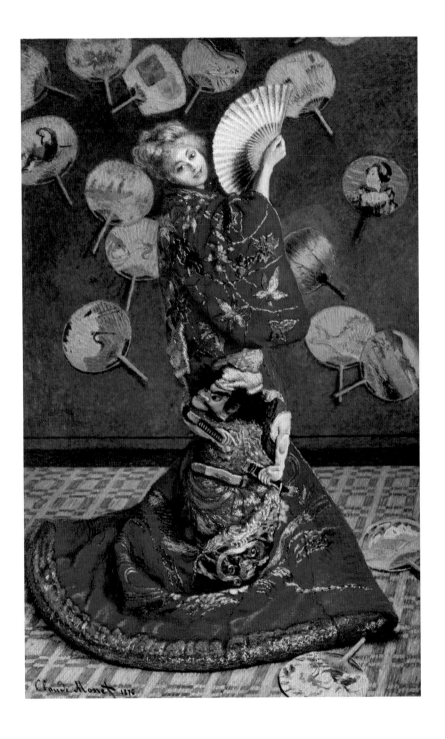

Gare Saint-Lazare

1877

Oil on canvas, 75.5 x 104 cm
Musée d'Orsay, Paris

The Gare Saint-Lazare in the Batignolles district was at the time Paris's newest station, an unmistakable symbol of a modern city. It was located in a quarter in which many of the Impressionist painters lived. Structurally, it used the latest architectural techniques employing iron and glass. Monet dedicated a series of paintings to the new station, the one shown here being one of the most famous. Steam shrouds the view, enveloping the shadowy shapes of the engines and the figures waiting nearby. In the background, behind a veil of smoke, we can make out the city with its typical residential buildings shown in sunlight.

With his highly sophisticated use of color, Monet manages to capture the lightness and rich shimmer of the steam-filled air. The violet, into which touches of yellow, pink, and blue are mixed, wonderfully captures the smoky atmosphere in the station. It seems as if we can almost touch it, almost smell it. For Monet, violet was the color of the air: "At last I've discovered the color of the air," he wrote; "it's violet, fresh air is violet. In three years, we'll all be working in violet." And in this way—to some extent as a patina unobtrusively covering the painting—he uses the color again and again. In contemporary reviews, the prevalence of violet tones in their palettes brought the charge of "indigomania" against Impressionists.

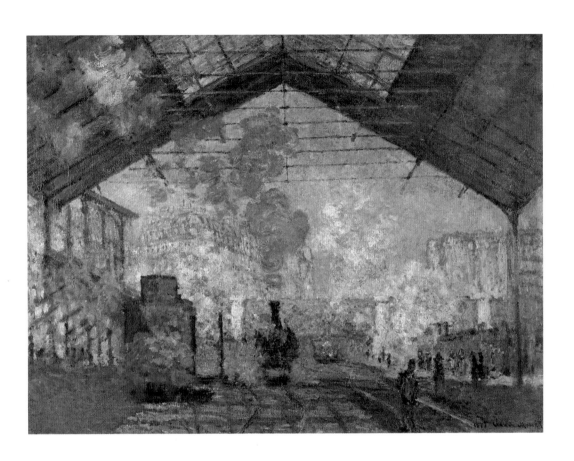

The Pont de l'Europe at the Gare de Saint-Lazare

1877

*Oil on canvas, 64 x 81 cm
Musée Marmottan, Paris*

"Painting has taken a step forward today, in this modern world with its beautiful grandeur," wrote Émile Zola; "Our painters have to experience the poetic in stations just as their fathers found it in woods and riverbanks." For the attentive eye of Impressionist painters, the city had numerous excitements to offer. The dynamic atmosphere in a station provided a welcome occasion to practice the art of capturing a fleeting moment of reality, a subjective impression. In Monet's picture, we seem really to hear—to quote Zola again—"the trains rumbling in ... see billowing clouds of smoke drifting up to the roof of the vast halls." Although Monet often painted railroad lines and stations, he had no interest in the social aspects of the introduction of railroads. Nor did he allude to any of the symbolism associated with the theme. What really interested him was the shimmering atmosphere of an urban landscape wreathed in smoke. The principle of painting a particular location in varying atmospheric conditions and thus capturing the differences in paint are among the most important characteristics in the work of Monet—a reflection on human perception that would reach a high point in his mature work, with the series devoted to haystacks, poplar trees, Rouen Cathedral, and water lilies.

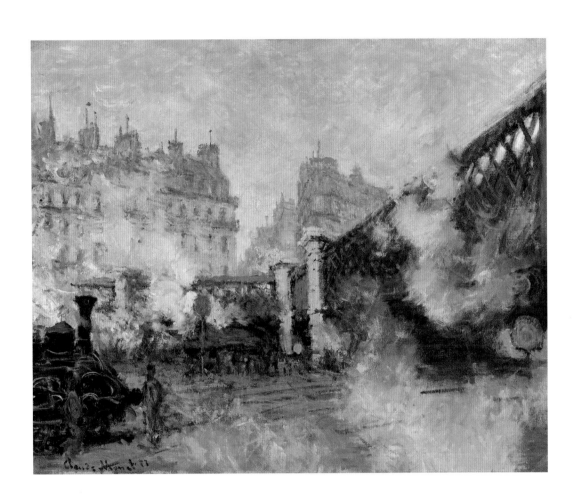

Rue Montorgueil in Paris,
During the Celebrations of 30 June 1878

1878

Oil on canvas, 81 x 50.5 cm
Musée d'Orsay, Paris

In this painting (a second version of which is now in the Musée des Beaux-Arts in Rouen), Monet looks down on the city from above. He is standing on the balcony of a house in the Rue Montorgueil. The 30 June was the day of the closing ceremonies for the 1878 World Fair in Paris. The very unusual perspective (inspired no doubt by the experimental views of the celebrated photographer Nadar) and the surprising immediacy of the pictorial treatment help viewers to feel they are right there in the middle of the celebrations and part of the relaxed mood of the moment.

The eye follows the steeply vanishing perspective down the street in the centre of the composition, but on the way lingers to glance at the façades and the fluttering flags. The very rapid, broken brushstrokes of Impressionism were perfectly suited to capturing movement. Monet placed rapid vertical and diagonal brushstrokes alongside each other with great skill, thus creating a convincing impression of a crowd milling along the street and of flags fluttering in the wind. Monet opted for a palette reduced to just a few colors— black, white, ochre, blue, and red; the whole picture is built on this very limited range of colors. The sky has a scattering of small fluffy white clouds that opens up the far distance, allowing the eye of the viewer to relax after traveling the length of the crowded street.

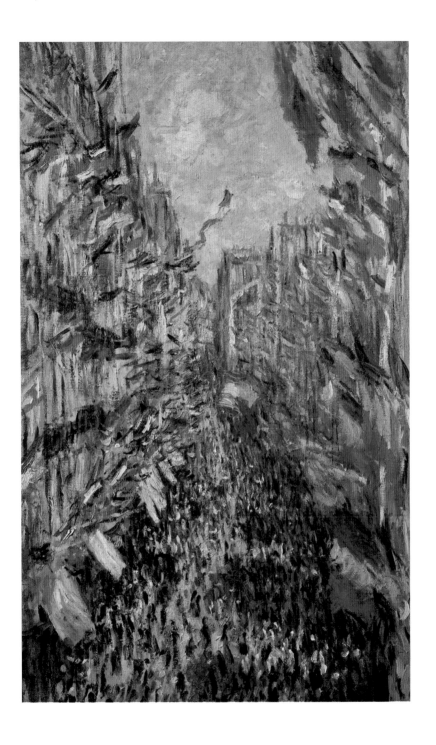

Camille on Her Deathbed

1879

Oil on canvas, 90 x 68 cm
Musée d'Orsay, Paris

The deathly pallor of Camilla on her deathbed intrudes into the otherwise serene visual world of Monet with tragic clarity. It is the 5 September 1879, and Camille has been seriously ill for a long time. For some years Monet has had a relationship with another woman, Alice Hoschedé, the wife of an important patron. But Camille, the mistress of his younger days and mother of his children, is still a vitally important figure in his life. Along with his complex confusion of feelings—love, the anguish of loss, perhaps even remorse—there is as always the artist's eye for color and light. More even than his wife's face, which is now only vaguely discernible, the focus is on the pattern of light that flickers across the picture. Camille's body is transformed to the point of unrecognizability, a dense network of broad brushstrokes in shades of violet interrupted only by the short, contrasting strokes of red (the flower petals in the bouquet she holds in her hands) and the turbulent dark strokes accentuating her face and chest. A leaden heaviness of almost Symbolist intensity prevails—a macabre, pained aura that even the quick brush and light palette of Impressionism are unable to dispel.

"One day, in the gray light of dawn, I sat at the bedside of a person who was very dear to me and always will be," confided Monet to a friend years later. "My eyes were rigidly fixed on the shattering sight of her temples, and then I caught myself following death drawing successive shades of color across her face with delicate mutations. Blue, yellow, gray, who knows. That's what it had come to with me. Then of course the idea surfaced of recording the image of the woman who had left us for ever."

Ice Floes at Lavacourt

1880

Oil on canvas, 68 x 90 cm
Museu Gulbenkian, Lisbon

In the winter of 1879–1880, the weather suddenly changed and the ice began to melt, with catastrophic consequences for the villages along the river. For Monet, the thawing ice represented a unique opportunity to depict the play of light and reflections on the surface of water, ice, and snow. Although nothing in the pictures on this subject indicates the tragic consequences of melting ice, there is a tense, deeply melancholy mood in the scenes that expresses the artist's state of mind following the recent death of his wife Camille from tuberculosis. To use the words of Marcel Proust, the pictures of ice floes painted between Lavacourt and Vétheuil come across "like a mirage"; in them, "we no longer know what is ice and what is sun, and all these lumps of ice break up the sky reflected in them, driving it forward like clouds, and the trees are so splendid that we no longer know whether the redness in them is due to the season or their species, and we no longer know whether it is a flowing river or a clearing in a forest."

Here again Monet reveals his ability to adapt the coloration entirely to the subjective impressions of his visual experience. He captures the restless, glittering color spectrum of the ice floes, the water, and the snow-covered river banks with their bare, slender trees. In the version shown here, the icy atmosphere of the moment is impressively rendered by the overlapping whites, grays, and browns.

Storm over Étretat

1883

Oil on canvas, 80 x 100 cm
Musée des Beaux-Arts, Lyons

"I've seen him capturing light glittering on a white cliff, recording it in a stream of yellow tones that strangely enough captured the surprising and fleeting effect of this intangible and dazzling glistening. Another time, he seized a shower of rain passing over the sea with his bare hands and threw it on the canvas. And what he painted in this way really was rain, nothing but actual rain."

These lines by Guy de Maupassant vividly describe how Monet tried again and again to capture changeable visual impressions in all their complexity on the limited surface of the canvas. The clouds, the sky, the water, the air are there on canvas—they are more real than a photograph and more intense than a memory. Monet set up his easel on the blustery Normandy coast and painted the lofty cliffs of Étretat with the wind blowing around his ears. He recorded the waves of a rough sea with edgy brushstrokes. It is so clearly different from the serene blue sea he painted in Bordighera or Antibes. "How real the spray of his waves whipped by a ray of light; how his rivers flow, speckled by the teeming colors of the things they reflect; how the light, cold gusts rise from the water in his paintings, into the leaves and through the blades of the grass!" wrote Joris-Karl Huysmans, and continued: "Pissarro and Monet finally emerged victorious from a terrible struggle. We may say that the great difficulties that light throws up for painting is finally solved in their paintings."

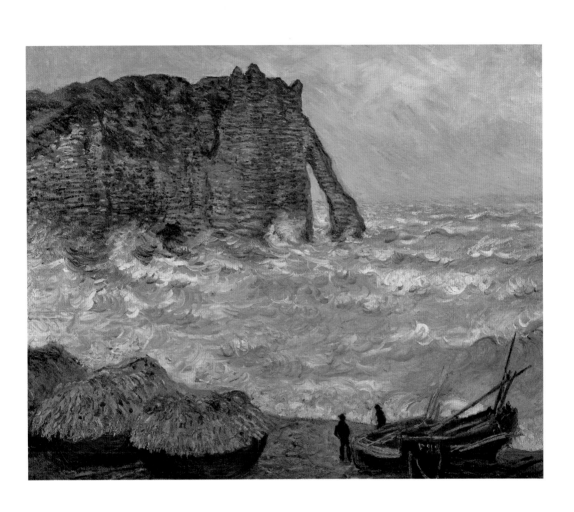

Storm over Étretat
(details)

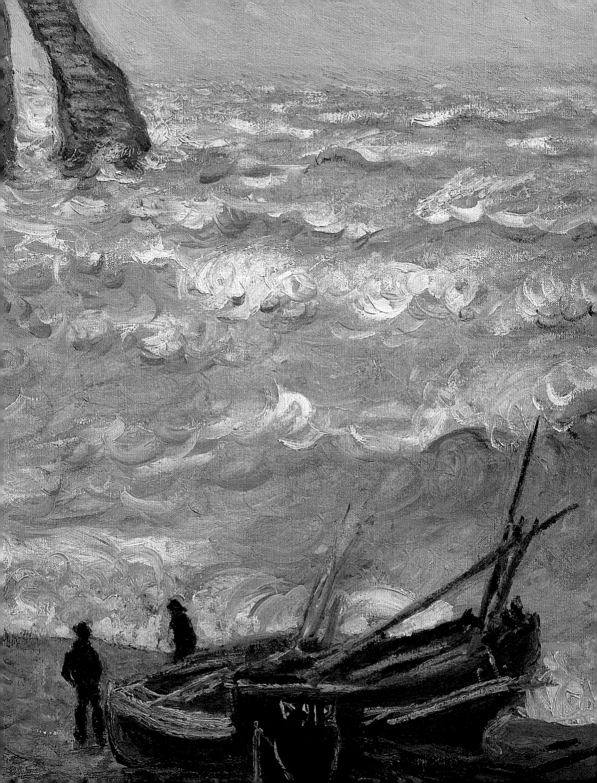

Villas in Bordighera

1884

Oil on canvas, 115 x 130 cm
Musée d'Orsay, Paris

During the second half of 1883, Monet took up the suggestion of his friend Renoir and traveled with him to the Côte d'Azur and to Liguria in Italy. Monet was particularly taken with the little Italian town of Bordighera, where he later returned alone so as to be able to work more concentratedly. "I'm in a true fairyland," he wrote to Alice, "I can't make up my mind which way to look first. Everything is so wonderfully beautiful, and I'd like to paint everything. ... For me, this landscape is something completely new that I have to study and that I am only slowly beginning to get to know. It is terribly difficult to know where to go and what to do. You would need a palette of diamonds and precious stones here."

Clearly Monet was deeply impressed by the beauty of the place, particularly the scintillating light and the colors of the Mediterranean coast. But he felt incapable of capturing the vivid spectrum of colors with his palette. "These palms have me in despair," he confessed, "and then the subject is extremely difficult to render and get down on canvas. This growth every-where—it's wonderful to look at, you could walk forever between palm trees, orange trees and lemon trees, even under the wonderful olive trees, but if you look for subjects, it becomes very difficult. I should like to paint orange trees and lemon trees standing out against the blue of the sea, but I can't manage to find what I'm looking for. And as far as the blue of the sea and the sky is concerned—completely impossible."

In Bordighera, Monet made the acquaintance of Francesco Moreno among others, who had a large estate nearby. The extensive garden of the villa, with its opulent Mediterranean and exotic vegetation, made a deep impression on the artist, who was himself a keen botanist. It became one of the main subjects of the works he painted in Liguria.

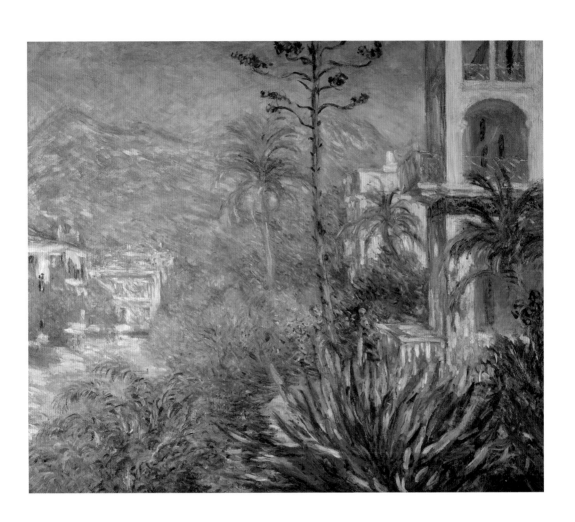

The Stacks at Port-Coton
(The Rocks of Belle-Île-en-Mer)

1886

Oil on canvas, 65 x 80 cm
Pushkin Museum, Moscow

Monet arrived on the Belle-Île-en-Mer, the largest island off the coast of Brittany, on 12 September 1886. He wanted to paint the coastal scenery, to depict rough seas from a new angle. The place so fired his imagination that he extended his two-week visit to two months. Monet seems to have been particularly fascinated by the rock formations off Port Coton, to which he devoted a whole series of paintings. In a letter to fellow Impressionist Berthe Morisot, he recounted how he had gone looking for an "awe-inspiring, somber and yet very beautiful" setting, and he had obviously found it in the rocks of Port-Coton. His recollections of those days, which art critic Gustave Geoffroy published in his book *Claude Monet, sa vie et son œuvre* in 1924, are famous. Geoffroy recounts how the painter had to fight the difficult weather conditions of the location, which made open-air painting extraordinarily difficult. Monet prudently tied his easel to the rocks, but had trouble using his brushes and paints in the strong wind. He fought tirelessly against the elements because he believed it was the only way he could capture the essentials of nature.
In a text about Belle-Île, Anatole le Braz has left us the recollections of an assistant to the painter: "Monsieur Monet enjoyed only the sea. He needed the water, more and more water, and the more of it he got, the more the spray of the waves splashed around the nose, the happier he was." Monet applied the paints from the spectrum of blues with energetic brushstrokes, and overlaid them with little white squiggles to indicate the foaming surf of the water breaking over the rocks. With these thick dabs of paint applied with a palette knife, he managed wonderfully to capture the raging of the wind-blown waves hitting the rock formations.

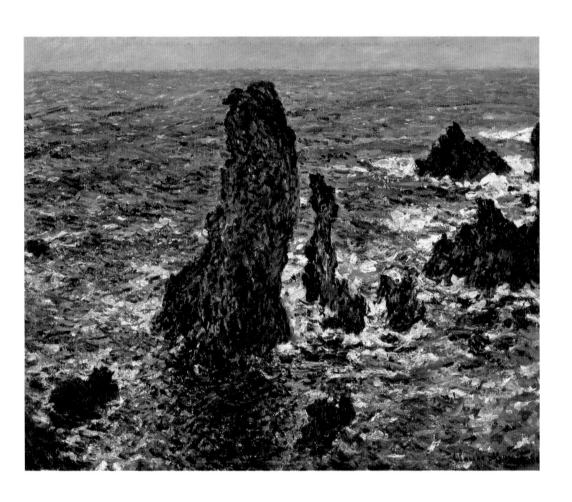

Boat in Giverny

c. 1887

Oil on canvas, 98 x 131 cm
Musée d'Orsay, Paris

Between 1887 and 1890, Monet painted several works for which his step-daughters Suzanne and Blanche Hoschedé acted as models. In this superb example painted in Giverny, we see the two girls in the company of a third female figure in a rowing boat on the Epte, a small tributary of the Seine. There are two other paintings by Monet with very similar subjects, one in the Museu de Art in São Paulo, the other in the National Museum of Western Art in Tokyo. In the version in Brazil, Monet opted for a very original composition. The boat has been placed in the upper half of the picture, so that part of it has been crop by the edge of the painting. The complex interplay of diagonals this creates lends the picture particular vitality. In the paintings in Tokyo and the Musée d'Orsay, on the other hand, he went for a classic composition in which the whole boat appears in the picture. The coloration, which in the São Paulo version has unexpected tones of orange on the wooden stern of the rowing boat, the clothes of the girls, and the swirl of weed on the clouded water, is much simpler here.

The dreamy, drifting mood of this picture, which has something enchanted about it, prompted many writers, then and later, to draw attention to its Romantic and Symbolist aspects. And indeed the stillness that permeates the scene does suggest such influences. Yet it is very improbable that Monet here abandoned his principle of the "direct look" in favor of a composition prompted by intellectual musings of the kind characteristic of the Romantics and Symbolists. His concern was always the elusive here and now.

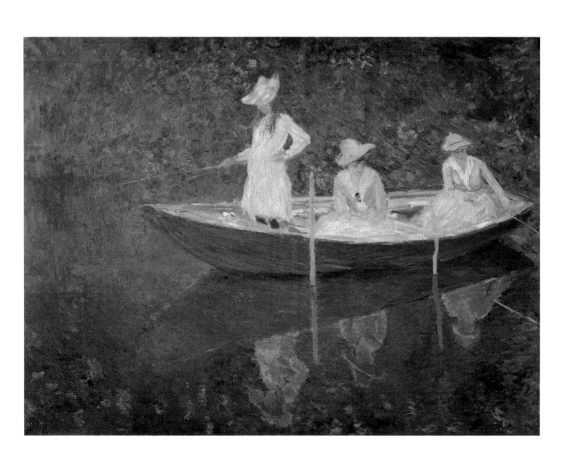

Antibes Seen from La Salis

1888

Oil on canvas, 100 x 81 cm
Museum of Art, Toledo (Ohio)

In his works painted on the Mediterranean coast, Monet attained a new degree of awareness in his long—and to the last relentless—struggle to capture a constantly changing reality. The artist was terrified sometimes to the point of despair when confronted with the intense light of these sun-drenched landscapes and the colors peculiar to them. In some views of Antibes and its surroundings, he went for a style that was in many respects akin to contemporary experiments by the Pointillists, and led to astonishing results.

That is true of this painting, which is one of the most interesting of the works painted on the Côte d'Azur. Shimmering with countless colors, the town rises from the shore of a tranquil sea. Monet painted the sea with long, relaxed brushstrokes in various greens, blues, and violets. Above it, we see Antibes and the sky, painted in diagonal strokes and scintillating colors. In the foreground are dark trees. In handling these, Monet returned to the rapid, broken brushstrokes so typical of French Impressionism, placing short squiggles of violet between yellow and green brushstrokes. After the dramatic seascapes of the north, Monet adapted his technique and palette to the new subjects. "After the Île Terrible," he wrote to the critic Théodore Duret, referring to Belle-Île, "it's all rather delightful. Here there's blue, pink, and gold." The tranquility of the place, the much more relaxed atmosphere, did not make it easier for him to paint, however. In his letters it comes out clearly that Monet increasingly despaired of his supposed incapacity to capture the warmth, light, and scents of Mediterranean landscapes on canvas.

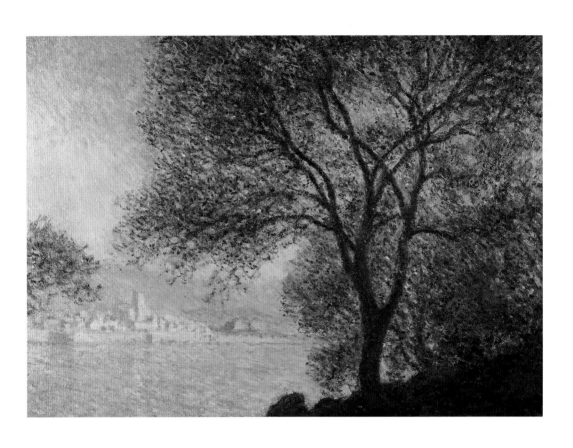

Haystack, Late Summer in Giverny

1891

Oil on canvas, 60 x 100 cm
Musée d'Orsay, Paris

The series of paintings that Monet devoted to haystacks may be seen as his first decisive step towards dispensing with a subject altogether so as to create works devoted entirely to the study of subjective perception and the dependence of visual impression on atmospheric conditions.

In an essay written in 1913, the Russian artist Wassily Kandinsky recalled how important the encounter with Monet's work had been for him in his search for a voice of his own: "Up till then, I'd been familiar only with naturalistic art," he wrote, "and to be frank, only the Russians ... And then suddenly, for the first time, I stood in front of a painting that represented, according to the catalogue, a haystack (!), but I couldn't recognize it at all. I felt greatly perturbed and annoyed by this failure to understand. I thought the painter had no right to paint so vaguely. I had the dull feeling that this work lacked an object, i.e. a subject. And yet I had to confirm with astonishment and amazement how surprising this picture was, and how indelibly it etched itself in my memory, all its details printed on my inner eye. "Initially all this was just confused in my mind, and I was not yet in a position to foresee the natural consequences of this discovery. What already stood out quite clearly was the incredible—to me hitherto unknown—force of a palette that went beyond my wildest dreams. This painting seemed to me filled with mythical power. But unconsciously, the real object (i.e. subject) had already lost importance as an indispensable component of a picture."

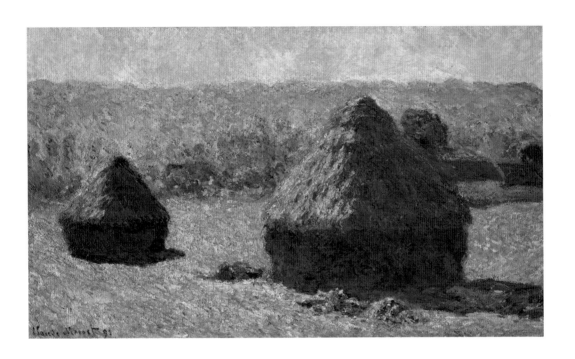

Poplars in the Wind

1891

Oil on canvas, 100 x 74 cm
Musée d'Orsay, Paris

"The unchangeable objects we think of as ordinary come into being in front of our eyes wholly new, as if we were the first human being, as if we had not yet learnt to recognize unchanged objects in varying lighting conditions the different external appearances to which these give rise," wrote the critic Octave Mirbeau in 1912 on the occasion of a solo exhibition by Monet.

A noted connoisseur and supporter of Impressionism, Mirbeau managed to sum up Monet's artistic creed in these few lines. It had its roots in Impressionism, but took the artist far beyond the elements of the movement he himself had founded twenty years earlier. After the series of haystack pictures, Monet began a series on poplar trees.

For this painting, he chose a long row of trees on the left bank of the River Epte. As he was painting it from his studio boat, it is shown in marked underview, the angle emphasizing the height and slenderness of the trees. As a result of this perspective, the works in the series as a whole have compositions with *japoniste* overtones, the graphic element becoming dominant. They are also notable for the contrast between the vertical and horizontal lines, between the first and second pictorial planes, and between the clear, slender poplars on the bank and the scarcely perceptible mass of the second line of trees farther back, whose wind-blown leaves are almost lost in the bright light of the sky. In order to continue painting the poplars on the bank of the Epte—he did more than twenty paintings of this motif— Monet had to pay a fee to the commune of Limez, which wanted to fell the trees for timber.

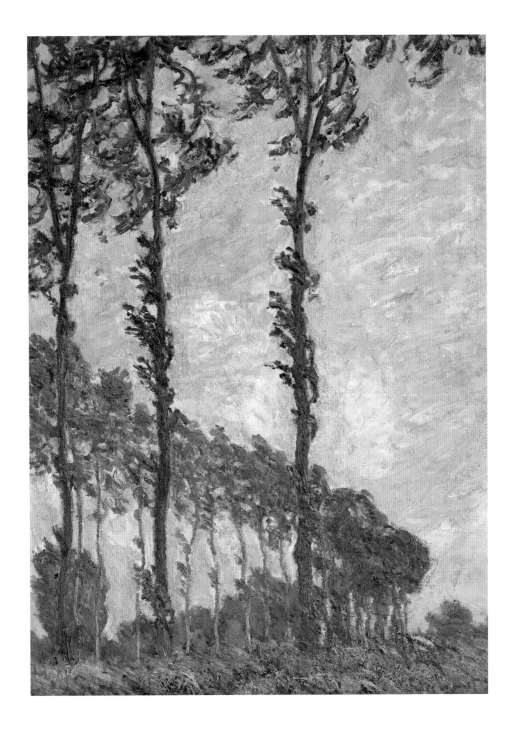

Rouen Cathedral in Gray Weather

1892 (but dated 1894)

Oil on canvas, 100 x 65 cm
Musée d'Orsay, Paris

In the 1890s, Monet painted a series of views of Rouen Cathedral, thus continuing the series principle he had begun with the *Haystacks* and *Poplars*—which meant working repeatedly on the same motif, whether it was a cathedral, a haystack, or a line of trees by a river, at different times. There is no especially profound reason for the choice of Rouen Cathedral. He probably made it the subject of his next series because the irregular, almost sculptural surface of the Gothic façade offered rich opportunities for his investigations into the nature of perception. The architectural structure of the building is subordinated to the actual interest of the painter, who observes how the light falls on the façade and how the whole moods of various times a day change under different weather conditions.

There is no narrative dimension to Monet's cathedral. Under the painter's brush it loses its objective character and is transformed into something altogether different—something subjective. It is not an object that is depicted but the effects generated by light falling on matter. This is precisely where Monet's works differ from those of other painters of the time, such as Alfred Sisley. Monet painted in the full awareness that it is impossible to reproduce objective reality—a notion of disconcerting modernity that would have far-reaching consequences for the subsequent development of art.

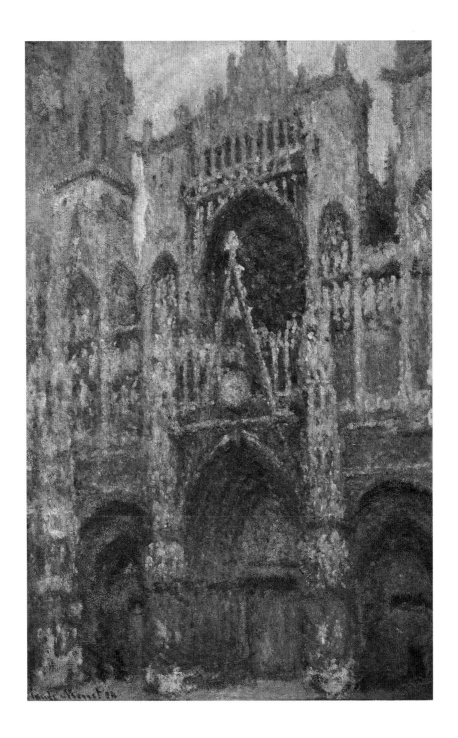

Rouen Cathedral, Morning

1892 (but dated 1894)

Oil on canvas, 106 x 73 cm
Musée d'Orsay, Paris

You have to look at more than one example from a series to really understand the point of these works. Only when you compare different versions do Monet's reasons for choosing a subject become clear. The façade of the cathedral changes noticeably according to the weather and according to the direction and intensity of the light falling on it. This is painting about purely subjective visual impressions, about what the eye of the artist sees at any given moment.

What Monet renders on canvas is ultimately an impression, a tangible representation of color sensations. He thus switches from the blue tones of sunny days to the brown tones of rainy days, from clear morning light to the hazy shadows of evening, in his search for the iridescent impressions that pass as quickly as his brush can get them down on canvas. Choosing a viewpoint very close to the façade seems to make it move towards the viewer, who can see how light almost shapes matter. And it is the light that transforms the huge, solid building now into an almost weightless filigree lace, now into a structure of solid stone. Isolating the façade from the rest of the building helps to detach the scene from its references in space and time, and to bring out the critical role that light plays in the perception of reality.

Georges Clemenceau summed this up in an article in the journal *La Justice* on 20 May 1895: "As long as the sun shines on it, there will be as many appearances of Rouen Cathedral as the units of time into which man is in a position to divide time. The perfect eye would be capable of distinguishing them all, since they are united in the vibrations that can be taken in by our present-day retina. Monet's eye goes on ahead of us, leading us in the Academy of Seeing that makes our perception of the world more penetrating and subtle."

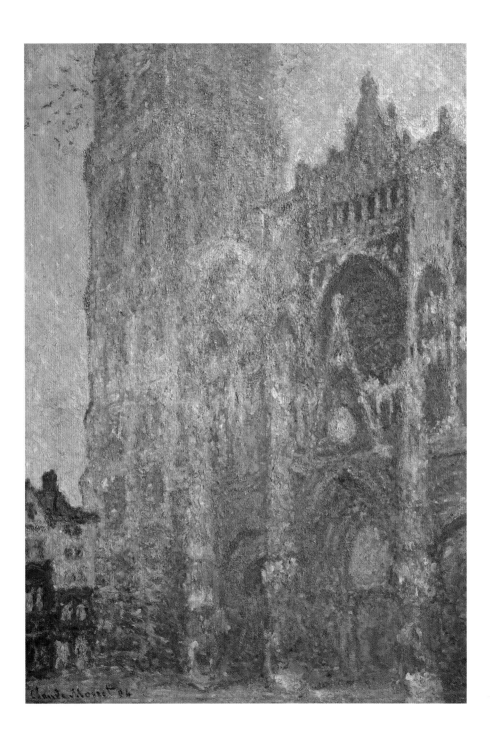

Water Lilies, Harmony in White

1899

Oil on canvas, 89 x 93 cm
Pushkin Museum, Moscow

Monet spent the last period of his long life in a house in the village of Giverny. There he laid out a large-scale water-lily garden that he described as a "water landscape." Painting these water lilies became a particular challenge: "These water landscapes and their reflections," he observed, "have become an obsession with me. They exceed by far the powers of an old man, and yet I will manage to transfer into art what my senses tell me. Many of them I will destroy … then I'll begin again."

Monet was now attempting far more than merely reproducing impressions. The water-lily pictures in fact represent introspective reflection, meditations on the secrets of nature and the incessant changes it undergoes. They mix sky and water, reality and reflections. Brushstrokes race across the canvas in rapid succession, and color no longer stops at the edge of the pictures. Every reference to the stabalizing physical presence of the buildings he included in his images of Rouen, London, and Venice, now vanishes. With the water-lily paintings, Monet advanced to the frontiers of abstraction.

In his last years, Monet was forever on a quest—an aesthetic project that had its counterpart more in the works of Marcel Proust than in the works of Émile Zola or Stéphane Mallarmé, who were otherwise so close to the Impressionist movement. In the leisurely pace and iridescent imprecision of his prose, Marcel Proust was looking for the same thing that Monet was looking for in paint. In the character of seascape painter Elstir in his multi-volume novel *Remembrance of Things Past*, Proust probably had an artist such as James McNeill Whistler or Paul César Helleu in mind rather than Monet, and yet the links with Monet are numerous and obvious. Just as Elstir "recreated things by taking their name away from them and giving them a new one," and "dissolved every frontier in the meeting of sky and sea," in his pictures from Giverny Monet made every spatial reference disappear in the forlorn hope of stopping time and of being able to capture it on the confined space of a canvas.

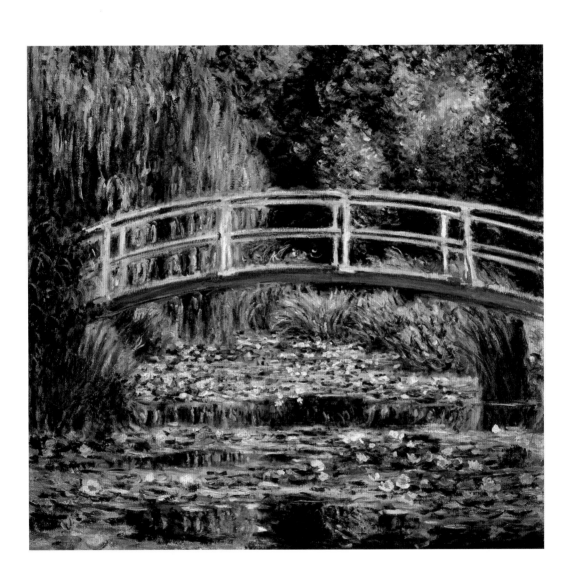

Water-Lily Pond, Harmony in Pink

1900

Oil on canvas, 89.5 x 100 cm
Musée d'Orsay, Paris

"This place, replete with almost unreal impressions, is accessed via an arched bridge such as is familiar from the landscapes of Hiroshige," reported Arsène Alexandre in 1921. "Wisteria winds along the railings of this bridge and hangs down in clumps and colorful stalactites, whose tips touch their mirror images in the waters of the Epte, just as stalagmites growing in limestone caves reach up to touch the stalactites hanging down from the ceiling. Because of its air of sadness, this frond of rubies, topaz, and amethyst inevitably appealed to Monet, and he made it the object of an extensive series of paintings. Among other things, one of these pictures is on show in the Camondo Collection, and right at the end the painter embarked on this awe-inspiring subject once again, expanded it, and painted it at a time of day when the sun made these precious stones glow."

The Japanese-style bridge was an overt tribute to Japanese art, which Monet collected keenly. It is in the part of the gardens that the painter loved most and constantly painted, at different times of the year, in different weather, and from very different angles. In a letter dated 1909, the artist describes his beloved botanical garden in the following terms: "There is a pond that I laid out myself about fifteen years ago. It is about 200 meters square in size, and is fed by a tributary of the Epte. Irises and mainly various water plants grow in it, framed by several kinds of trees, principally poplars and weeping willows. And that is the place where I painted the water lilies with a bridge built in the Japanese style."

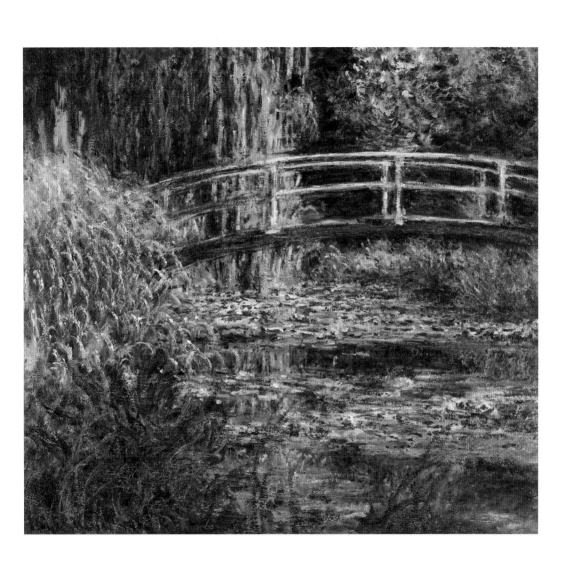

View of Vétheuil

1901

Oil on canvas, 60 x 92 cm
Pushkin Museum, Moscow

In 1878, Monet began to paint landscapes of Vétheuil. From then until 1881, the little town on the Seine became one of the artist's favorite places. He painted various parts of it from different angles in almost two hundred pictures.

This version, however, dates from the early years of the 20th century, when Monet returned to Vétheuil for a time. "Dear Monsieur Durand," he wrote in a letter in 1901, "you would no doubt be amazed and perhaps a bit angry with me if you saw how much time I need to supply you with the pictures. I am so sorry because I am working as hard as I can, and at the moment need endless time to gets something good done. Assuming it comes off at all. I have begun a series of pictures of Vétheuil, which I thought I could finish quickly, and which in the event have taken the whole summer, which means that all the others remain half finished."

In comparison with the earlier versions, it is notable in this late work that the town of Vétheuil appears only sketchily in the background. Monet concentrates here entirely on rendering the surface of the water, which had become a real obsession. The opalescent shimmer of the colors also draws a line between this and earlier scenes of the same subject. In many respects, it is reminiscent of the palette that his friend Auguste Renoir used for preference in these years. The pattern of horizontal, vertical, and diagonal lines that otherwise features in his landscapes is here less prominent. The free brushwork causes objects to lose their tangibility; they now seem to dissolve in vibrations of light.

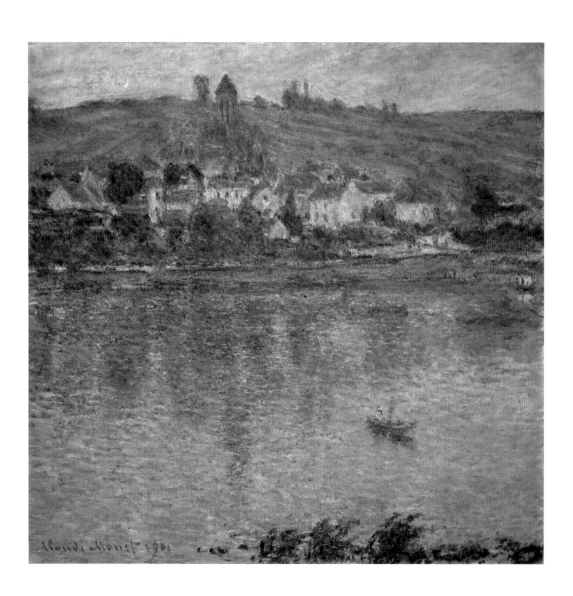

Houses of Parliament, London

1904

Oil on canvas, 81 x 92 cm
Musée d'Orsay, Paris

Throughout his career Monet was fascinated with the surface of water. Water represented the steady, unstoppable flow of existence, the mutability of nature that fascinated so many artists, musicians, and writers of this time, from James McNeill Whistler to Claude Debussy and Marcel Proust, and Monet wanted to capture it on canvas in his series of paintings.

He therefore saw a visit to London as a welcome opportunity to paint a "water landscape" in which perception is obscured by the effect of light and mist. The classic phase of Impressionism, in the 1870s, was now long past. Monet was still working with the same basic principles worked out then, but now taking them to their logical conclusion. In this way, he arrived at a visionary and emotionally moving style. The brushwork is freer, the forms dissolve in color, and objects lose their materiality. They seem to exist in the vibrant light that gives them momentary form.

A comparison of this painting from the mature phase of the artist's work with a version of the same subject he painted as a young man is highly instructive. The bright, iridescent palette of early Impressionism has been replaced by a much more complex spectrum of colors combining violet with flaming orange and tones of purple and red. The figures standing on the jetty that were obviously still necessary in the composition of 1871 (see page 57) have now disappeared. The sole protagonist is the imposing mass of Charles Barry's Neo-Gothic building, which seems to dissolve in the mist, like its own reflection. Whereas the first version still resembled a cityscape, the later is closer to a painterly treatise of the perception of refractions.

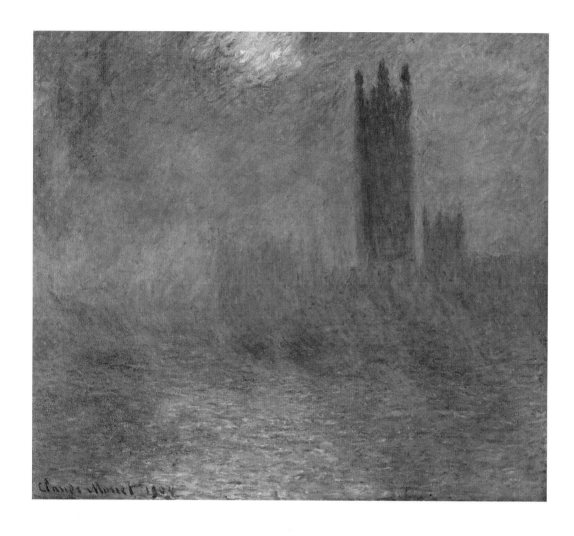

The Doge's Palace

1908

Oil on canvas, 81 x 100 cm
Brooklyn Museum of Art, New York

Monet called Venice "Impressionism in stone," and it is hardly surprising that on his trip to Italy he succumbed to the charms of the Serene Republic, the city that seems to float on water. The drama of the Gothic buildings reflected in the waters of the canals was tailor-made for the Impressionist technique.

In the course of a lengthy stay (from 2 October to 7 December 1908) he painted around forty canvases. The Doge's Palace was among his favorite subjects. It undoubtedly was the delicacy of its lacy, pierced façade, the rhythm of its arches, its prominent position in the city, and its fame that influenced his choice of this subject.

The waterline divides the picture into two halves, a compositional scheme that the artist used several times. The building stands in the upper half, its substantiality muted by the effects of the flickering light of a sunny day. In the lower half, on the other hand, water is the uncontested protagonist. "The artist who dreamt up this palazzo was the first Impressionist," wrote Monet, "He got it to rock on the water, rise from the water, to radiate in the Venetian air just as Impressionist artists get their paintings to radiate from the canvas in order to convey atmospheric sensations. When I painted this picture, I wanted to paint the atmosphere of Venice. The palace that features in my composition was just an excuse for painting the atmosphere. All Venice is bathed in this atmosphere. Swims in this atmosphere. Venice is Impressionism in stone."

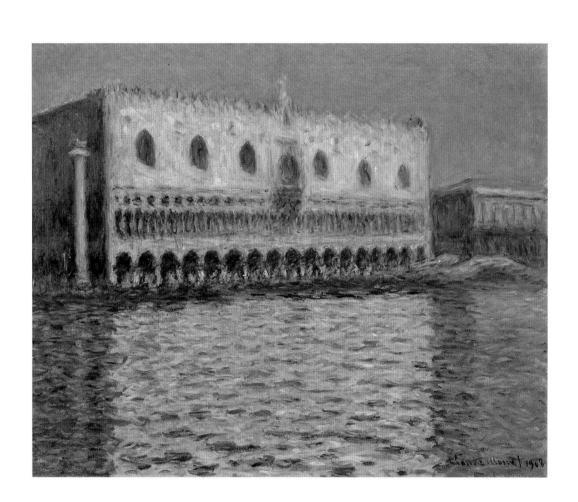

Water Lilies, Morning

1914–1926

Oil on canvas, two canvases 200 x 212.5 cm, plus two canvases 200 x 425 cm
Musée de l'Orangerie, Paris

Around 1890, Monet retreated to his own small paradise provided by his house in Giverny, with its water garden. In his last years he painted virtually only water-lily pictures here, and continued to work despite serious problems with his eyes, though with great difficulty.

In 1919, Monet presented twelve paintings to the state that he had executed between 1914 and 1918. They were to be exhibited in the garden pavilion of the future Musée Rodin; yet, despite the support of Prime Minister Clemenceau, the project was not approved, so the paintings ended up in the Orangerie at the Tuileries. Monet himself supervised the conversion of the rooms in which his large-format canvases of the water garden in Giverny were to be shown. Truly monumental in their format, the paintings were to cover completely the walls of an oval room.

The result was an extraordinary installation. The viewer is totally submerged in the indistinct, shimmering atmosphere of the water-lily pond, which the painter recorded under a range of different conditions. The "painter of the impossible," as Monet is often called, here attained the zenith of his preoccupation with the perception of light and its reflections and refractions.

Monet devoted the final years of his life entirely to the botanical paradise of Giverny. He collected and tended hundreds of plants for the garden pond, an aesthetic venture that went far beyond the purely picturesque. The garden was "the only major luxury that Monet allows himself," thought Jean Lorrain in an article in *Le Journal*. The painter "spends 40,000 francs a year on this Garden of Eden."

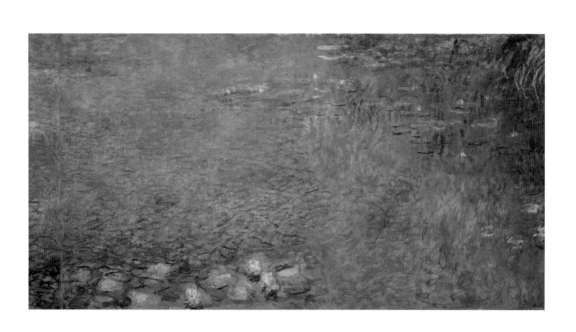

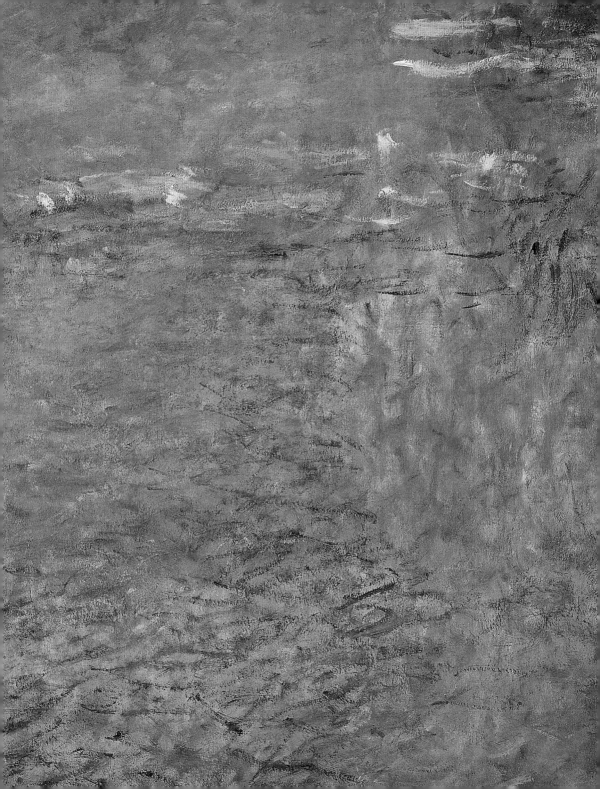

Water Lilies, Blue

1916–1919

Oil on canvas, 200 x 200 cm
Musée d'Orsay, Paris

In June 1909, art critic Roger Marks, who at the time exercised the office of Inspector of Fine Arts, published a euphoric account of Monet's water-lily pictures in the *Gazette des Beaux-Arts*: "Monsieur Claude Monet intends to do away with the earthbound setting that delimited the horizon, that terminates and 'fixes' the composition. He shifts his viewpoint, with the result that the bank retreats and soon disappears. It is scarcely visible at the top of the early paintings: a narrow strip of land encircles with verdure the slight thinning of the wooded area, which the floating clusters streak with speckled moiré. No more earth, no more sky, no more limits; the still and fertile waters completely cover the canvas; light overflows, gaily playing on the surface covered with green and copper-brown leaves. Water lilies rise from it, stretching out their white, pink, yellow or blue flowers towards the sky, as if they thirsted for air and sunlight.

The artist deliberately shakes off the traditions of Western painting. He dispenses with the vanishing lines of the visual pyramid that directs the eye towards the centre of attention. What is shown as firm and unchangeable contradicts the principle of fluidity; he wants our attention to be diffused and scattered. He considers himself free to change the gardens of his little archipelago wholly according to his own needs, placing them right, left, top or bottom on the canvas."

In closing, Roger Marks makes a comparison with fabric patterns—it was no accident that some of the water-lily pictures were used by state manufacturers as patterns for fabrics.

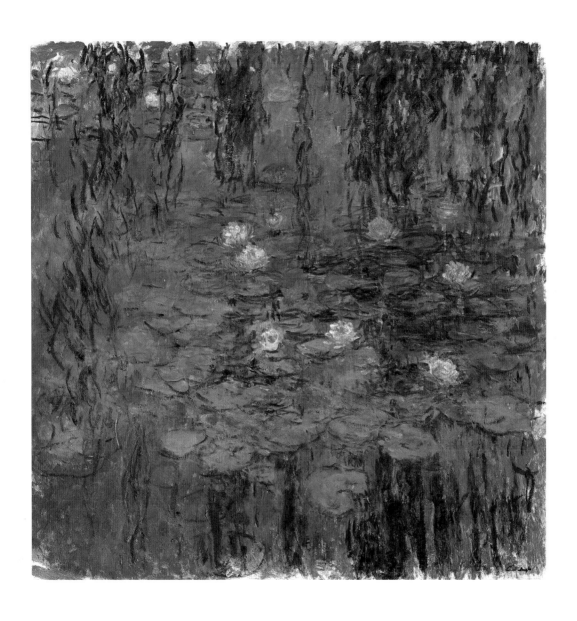

Weeping Willows, Morning

1914–1926

Oil on canvas, left section, 200 x 425 cm
Musée de l'Orangerie, Paris

"There is a visit to Monet that even Bonnard, Ker Roussel or Vuillard will not forget, when Monet invited us one late summer afternoon to look at all the water-lily pictures that were almost ready and of which we had so far seen only the first. He and his stepdaughter told us to sit in the huge studio that he had had specially built at the edge of his garden.

Then they carried the pictures in, shifted them, turned them round until we were finally surrounded by a sequence of pictures, then by a second. They were to imitate the two rooms in the Orangerie. ... When the astonished visitors now tried to express their amazement, he said, after listening to them with a smile, that he was glad to hear what his young friends said, it gave him confidence again, as he confessed he was not completely convinced himself and was fighting self-doubts. Otherwise he said nothing. Nor did the others, they just went on looking greedily at the pictures, until they finally had to detach themselves from this wonderful drama that would never let go of any of us again."

In these memoirs from 1948, published as a volume in the series *Peints à leur tour*, the publisher Thadée Natanson obviously wanted to emphasize the defining role that Monet would have for the next generation of artists. Pierre Bonnard, Ker Xavier Roussel, and Édouard Vuillard could not avoid—and the same applied to many others at the turn of the century—coming to grips with the example of this great artist. Even though new artistic movements came to the fore, Monet's gaze at the world (Paul Cézanne called him "the great eye") and his obsessive passion for reality in all its refractions met with keen interest and admiration. His achievements remained an indispensable starting point for the artistic explorations of the new generation.

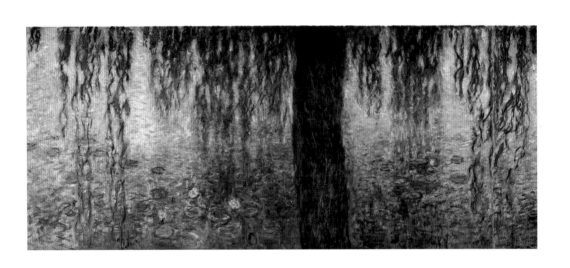

The Japanese Bridge in Giverny, Version II

1918–1924

*Oil on canvas, 89 x 100 cm
Musée Marmottan, Paris*

The Japanese Bridge in Giverny, Version II offers viewers who try not to get lost in the shimmering color weave of water and vegetation nothing to take hold of. This painting has reached the point of abstraction that Monet had come close to in earlier pictures of the same subject.

"The colors no longer had the same intensity for me, I was no longer painting the light effects with same precision. The tones of red became muddy, the pink tones paler and paler, and I was simply unable to hit fine intermediate tones nor the deepest tones. I could still see the shapes with the same clarity and draw with the same precision."

The loss of sight, which was already very restricting, undoubtedly helped to bring the artist to this low point. But behind the stylistic orientation that was very personal to him, an intellectual motive, a conscious urge, can be discerned. Monet seems not to be looking at the world in front of him anymore, but to be perceiving the light from within himself.

It is a new relationship with reality that prompts Monet to take the utmost (and last) step in his exploration and rendering of nature. He had always seen his achievement as "painting directly from nature, trying meanwhile to render my impression of the most fleeting phenomena." But in fact Monet had flung the door to abstraction wide open, anticipating it with the free technique and coloration of the late world—even if he himself remained a man of the 19th century who clung unfazed to the notion that there must be a visual object in the picture, and who therefore was not in a position to understand those who, even in those years, championed abstract art.

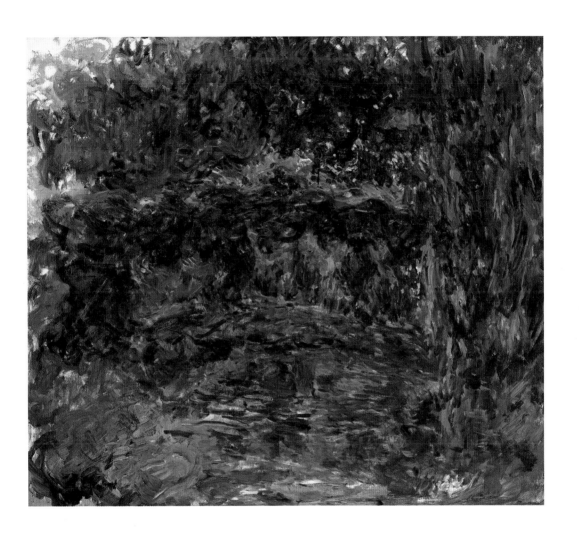

THE ARTIST AND THE MAN

Monet in Close-Up

Monet's beginnings: from Boudin to Manet

A gifted caricaturist, Monet first exhibited his drawings in a frame-maker's shop in Le Havre when he was sixteen. And it was there that the artist Eugène Boudin, whose own works were being shown in the shop, became aware of the young man's technical skill and artistic sensibilities, and decided to make his acquaintance. "Boudin came directly up to me and said: 'I always enjoy looking at them, your sketches. They're amusing, well done, and full of life. They show talent, one sees that at once. But I hope you won't leave it at that. It's very good for a start, but you'll soon have had enough of drawing caricatures. Do what I do, learn to draw well and to appreciate the sea, light, the blue sky.'"

In the same letter to Gustave Geffroy, written in 1920, Monet continues: "I followed his advice, and together we went on long walks during which I painted from nature constantly. That's how I came to understand nature and to love it passionately, and how I developed an interest in Boudin's high-keyed paintings. Don't forget that Boudin had studied with Jongkind, whose works ... stand with Corot's at the beginning of what would later be called Impressionism. I said it once, and I'll say it again gladly: I owe everything to Boudin, and I attribute my success to him."

Monet first exhibited at the Salon in Paris in 1865. He was still very young (in his mid-twenties), though the fact that he mentions no teacher in his account of himself (it was usual for artists at the beginning of their career to cite their teachers or mentors) is an indication of a certain degree of self-confidence. The two paintings the jury accepted were landscapes of the mouth of the River Seine at Honfleur on the Normandy coast; one of them could be a painting now in a private collection. As the paintings at the Salon were hung alphabetically according to the artist's name, Monet's works were in the same room as those of Édouard Manet. Manet had been a controversial figure ever since his *Déjeuner sur l'Herbe* (which has two clothed men and a nude woman sitting in a landscape) had been shown, in 1863, and his submission in 1865—*Olympia*—was causing further uproar.

The similarity between the two surnames led to some confusion. At the opening of the exhibition, the older painter—who was highly regarded by his younger colleagues, including Monet—was understandably less than enthusiastic about being praised time again for his splendid seascapes! When he then looked at the signature on the pictures wrongly attributed to him, he initially thought someone was playing a joke: "People congratulated me for two pictures that are not by me," he confessed to a friend; "We have to assume a nasty piece of deception!" Even when the misunderstanding had been cleared up, Manet was left with the rankling knowledge that the two seascapes by the young painter had been far more widely admired than his own paintings.

In fact the reaction to Monet's first showing was very positive. "From now on, we will follow the future works of this serious seascape artist with interest," wrote Paul Mantz in the *Gazette des Beaux-Arts*. Other critics followed his example, and praised the qualities of the young artist. Manet, however, had difficulty in swallowing his chagrin, and for months harbored a certain grudge against Monet, whose offense was simply to have a similar name. When Zacarie Astruc, who was a friend to both men, suggested introducing Manet to the young painter, Manet categorically refused. They met only much later, a meeting that proved wholly beneficial to both men, for it led to a close friendship based on deep mutual respect.

The Café Guerbois, Claude and Camille

During the 1860s, the Café Guerbois was the later Impressionists' most important rendezvous, a distinction that was later granted to the Café de la Nouvelle-Athènes. At the Guerbois, Manet held sway, giving advice on matters of art and life to the younger habitués. This was also where writers such as Émile Zola and Louis-Émile Duranty took on their roles as defenders of the new art.

Monet too was also a regular at the café. But although by now he was uncontested leader of the "little band of landscape painters" who went out painting with him in the open air to escape the confines of the studio of Charles Gleyre, where they studied, at the evenings in the café he tended to remain in the background. Monet had little interest in art-historical discussions of the kind relished by better-educated artists such as Manet and Degas. He preferred to listen, trying to understand the ideas and secrets of the artists he admired.

In his *History of Impressionism*, John Rewald suggests that the Guerbois helped Monet to overcome the feeling of being completely isolated that afflicted him from time to time during his solitary spells in the country. It undoubtedly did him good to meet up with warm-hearted friends who shared his interests and who encouraged him to continue on his own path, undeflected by the mockery or hostility of critics and the public.

In 1866, Monet decided to undertake a figure painting of a woman in a green dress. To execute this work, which was later well received at the Salon, he hired a young model, Camille Doncieux, and immediately fell in love with her. The supposed immorality of this liaison caused a breach with his family, who stopped the financial support that was essential if he wanted to stay in Paris.

Monet's mother had died some time before, and his relationship with his father had long been a troubled one.

This difficult situation, however, was made a little easier by his aunt, who had always supported her nephew's artistic ambitions and who tried to intervene on his behalf. The discovery that Camille was pregnant naturally made things worse.

In 1867, Monet's close friend Frédéric Bazillle wrote a letter to the artist's father telling him of the financial difficulties the couple had to face, and asking him to help. All he got was the dry, terse reply stating that Monet was welcome in the family and that Madame Lecadre (his aunt) would doubtless greet him with open arms—on condition that he parted company with the model.

In this situation, Monet had no other choice than to leave the pregnant Camille alone in Paris and to move back to his family, staying with his aunt in Sainte-Adresse near Le Havre. When the young woman brought their first son, Jean, into the world in July, Monet didn't even have the money to visit her. So he asked Bazille to act as godfather and to take care of the mother and child.

Claude and Camille made their relationship official in June 1870, when they finally got married. It was a comparatively short but intense marriage. Already in 1878, after the birth of their second son, Michel, the young woman fell seriously ill with tuberculosis. On the morning of 5 September 1879, she died after a period of terrible suffering. Monet was left in despair "alone with my poor children," but also with the comforting presence of Alice Hoschedé, the wife of a patron, who had become his lover.

A picture in hock

Two fragments of paintings in the Musée d'Orsay are all that is left of a monumental work Monet had begun in 1865. He had planned a scene with figures sitting beneath the foliage of a tree as a tribute to Manet's *Déjeuner sur l'Herbe*—that much is immediately evident from the use

of the same title. Friends and acquaintances including Camille, Bazille, and Gustave Courbet acted as models. The project was highly ambitious even for its very large dimensions, the canvas measuring over 4 by 6 meters (13 by 19 ft). But it soon became clear to Monet that he would not finish the picture in time for the Salon. So he stopped work on it in order to devote himself wholly to the figure painting mentioned above, *Camille in a Green Dress*, which proved to be a great success.

Monet himself reported what happened to the large canvas: "I had to pay my rent, and so I left the painting as a pledge with my landlord, who rolled it up and put it in the cellar. As you can imagine, ages passed before I finally had the money to redeem it, by which time it was covered with mould." Monet collected the painting in 1884. He was able to save three fragments, but had to throw the rest away. One of these fragments—depicting a group of figures under a tree on the right—was lost after the artist's death. Moreover, the central fragment was later cropped on the right, as we can see from a photograph from 1920 showing the fragment as originally cut up by Monet; in it, another now-lost figure can be made out.

Painting in the open

In 1866, Monet began work on a composition depicting four women in a garden. Since his *Déjeuner sur l'Herbe* had been a failure the previous year, he now used a canvas of a less ambitious format. However, he would not be dissuaded from his idea of doing this work—still notable in its dimensions, being 2.5 by 2 meters (over 8 by 6.5 ft)—completely out of doors.

It was a bold and novel idea. Even the painters of the Barbizon School, from Camille Corot to Charles-François Daubigny, as well as the Realist Courbet and the great Manet, all of them models for Monet, considered work in the studio to be indispensable. Often they confined themselves simply to doing drawings and quick sketches in the open air, which they later worked up in the studio. In order to be able to paint his picture completely out of doors, Monet had to solve a number of technical problems. As the dimensions of the canvas made it impossible to use a normal easel, he designed a peculiar contraption, a kind of winding gear, with which he could raise or lower the canvas depending what part he was working on.

"I did indeed paint this picture on the spot, from nature, which was not at all customary at that time," he explained years later. "I dug a channel in the ground, a kind of trench into which I could lower my canvas bit by bit so that I could paint the top parts of the picture. I worked in Ville-d'Avray, where I sometimes got advice from Courbet when he came to visit me." It was in these extraordinary circumstances that one of the early Monet's most famous masterpieces came into being. But critics were not impressed by the work. *Women in the Garden* was rejected by the jury at the Salon, and was at first admired only by progressive contemporaries such as Zola.

Though producing it must have been very challenging from a practical point of view, the work was highly innovative in terms of both content and technique. A scene with four women in a garden possibly goes back to a photographic original (in 1937, Gaston Poulain drew attention to a photograph of three cousins of Bazille's in a garden that displays great similarities with Monet's composition), or possibly to contemporary fashion graphics, which were very common that the time and must certainly have been familiar to Monet. But what makes the scene so special is mainly the painter's fundamental indifference to the supposed subjects of the picture, which he neglects in favor of atmosphere and mood, and the play of colors and of light and shadows. The fact that Monet used the same model,

his partner Camille, for three of the women clearly indicates that he was not interested in a group portrait.

New paints and new art

One of the most interesting and perhaps least-known aspects of the Impressionist revolution was the use of "new," synthetic paints made of chemical pigments, which were still rejected by the Academy at the time because they ran counter to traditional working methods and sensibilities.

Recent research has shown that twelve of the twenty most important paints in the Impressionist palette were synthetic pigments. In some of Monet's paintings, for example the *Regatta in Argenteuil* now in the Musée d'Orsay, they can be clearly discerned. Synthetic colors made a vital contribution to the innovations introduced by "Les Intransigeants." For example, the range of blues had been enriched from 1802 by the invention of cobalt blue, a much cheaper substitute for natural ultramarine. An artificial ultramarine was added in 1828, followed by a sky-blue (cerulean), which came on the market in 1860. Of fundamental importance for the Impressionist palette are also various greens, principally emerald green. The discovery in 1797 of the element chromium by the French chemist Nicolas Louis Vauquelin had made a series of new yellow, orange, and red tones available. From 1868, moreover, two new violets were added, cobalt violet and manganese violet. The quest for "the color of air" to which Monet had devoted himself in the heyday of Impressionism was made possible by these new pigments.

Studio on the river

When Émile Taboureux, the editor of the periodical *La Vie Moderne*, asked Monet to show him his studio in 1880, the artist replied: "My studio? I never had a studio, and I don't understand why one should shut oneself up in a room. Possibly to draw, but not really to paint. ... As far as I'm concerned, this is my studio," he continued, with an expansive gesture embracing the panorama in front of him—the Seine landscape at Vétheuil.

Taboureux also mentions Monet's two boats. In one of them, the journalist noted, "he goes for a trip when he wanted to work up an appetite before supper." In the other, he simply observed, "he works," but he saw no significance in the fact ("the boats that belong to Monet are no different from other people's boats," it says a few lines later). The second boat was, in fact, of great importance for Monet; it was presumably the famous *bateau atelier* that he painted several times and that also features in a painting by Manet, *Claude Monet Painting on his Studio Boat* of 1874 (Neue Pinakothek, Munich).

Monet had acquired his boat in 1872 when things were going relatively well for him financially after a number of major sales. It was equipped like a small studio, and was big enough for him to overnight in. Monet used the boat to paint the Seine and its tributaries from unusual angles, a task that took him up and down the river between Rouen and Argenteuil time and again.

The immediate predecessor of Monet's *bateau atelier* was undoubtedly Charles Daubigny's famous houseboat, which was called *Le Botin*. One of the most important landscape painters of the previous generation, Daubigny had specialized in river views, among other things. Monet had been an admirer of Daubigny's work from his youth, and when the two of them were in London at the same time in 1870, escaping the horrors of the Franco-Prussian War, Monet had an opportunity to get to know the artist personally and they became friends. It was through Daubigny that Monet made contact with the important gallery owner Paul Durand-Ruel, who would play a key role in promoting Monet's work both at home and abroad.

Incidentally, Monet was not the only one to appreciate the advantages of a studio boat. The American-born artist James McNeill Whistler, who was also in London at the time, copied Daubigny's example and went down the Thames in a small boat looking for subjects.

The "Raphael of water"

It was Manet who called Monet the "Raphael of water," keenly appreciative of his young colleague's sensitive and closely observed depictions of a motif that was of great significance for Impressionism.

Monet was obsessed with water. It allowed him to observe a ceaseless play of color and light, transient and intangible effects that he struggled tirelessly to capture in paint. Water represented for him the steady, incessant flow of existence, the unending transformation of nature.

That is why Monet explored the infinitely diverse aspects of water in its many forms: still waters, flowing or frozen rivers, the waves of the storm-tossed Atlantic coast, the gleaming, sun-drenched seas of the Mediterranean. Every type of water had a special quality, something characteristic that the painter simply had to capture through the appropriate choice of color and painting technique. Small colorful squiggles for the waves of the sea off the north French coast, horizontal brushstrokes for the flowing Seine, soft fluid lines that overlapped and dissolve for the water in the flower-strewn pond in Giverny.

In the second half of the 19th century, water was a central feature in the artistic outlook of many painters, writers, and musicians. It was the theme in compositions such as Claude Debussy's symphonic sketch *La Mer*, for example, it came alive in the paintings of the Impressionists, and at the end of the century it also became a dominant motif in literature. In none of these works do we find a precise description of water, rather an attempt to capture its essence.

As the poet Stéphane Mallarmé knew, an excess of visual information and detail actually weakens perception.

An intangible, fugitive element that makes a very apt symbol of the unfathomable depths of human existence and eternal life, water also represents the variability of perception, a theme that fascinated the Impressionists, above all Claude Monet.

Monet had such a marked gift for rendering light and its reflections that a contemporary critic, Alfred de Lostalot, speculated that the artist had preternatural sight and was possibly able to perceive ultraviolet light. Certainly his incontestable visual sensitivity explains some characteristics of his use of color, his palettes notable for very complex and unusual color tones and harmonies.

The darkest tones in his best-known paintings, for example the Gare St. Lazare, were produced without using earthy colors, but solely by mixing synthetic colors ranging from cobalt blue to emerald green. The thick and complex application of paint in mixed tones was necessary in order to represent shadows, which according to the Impressionists were not just black but rich in colors. Brown tones were produced not by the use of earth colors but by mixing vermilion, cobalt blue, cerulean, green, red, and chrome yellow. In other cases, Monet chose the opposite solution and used exclusively pure pigments. The result was just as innovative.

The Impressionists and "indigomania"

In Monet's paintings—and this applies to Impressionist works generally—a predominant color prevailed, which, given the academies' preferred "gallery tone" (i.e. the harmonious attuning of colors to brown, red and other warm tones), constituted a direct challenge to the past.

In one of his books, Joris-Karl Huysmans nursed the whimsical hypothesis that the Impressionists suffered from

a peculiar disease he called "indigomania," which was expressed in the unmistakable preference for the color violet, which frequently dominated their palettes. This excessive use of violet and purple in Impressionist paintings was lamented by many contemporary critics and was often mocked. They talked of a collective obsession, going so far as to claim that an epidemic of color blindness had broken out.

The Impressionists rejected the use of black, claiming that it does not occur in nature, while using violet in great quantities in rendering the color of the atmosphere. "I've finally discovered the color of air," wrote Monet; "It's violet, fresh air is violet. In three years, we'll all be working in violet." The complementary color to the yellow of sunlight, violet was also the preferred color among the Impressionists for rendering shadows, the use of color to create shadows being one of the key innovations of Impressionism. These intuitively grasped connections, which were supported by scientific discoveries in physics and optics, would later be taken up and developed by the Pointillists, notably Paul Signac and Georges Seurat.

Durand-Ruel: Monet's first dealer

Monet had a rather open relationship with dealers, only rarely granting any single dealer exclusive rights. He made no exception even for Durand-Ruel, to whom he undoubtedly owed a large part of his success as a result of the latter's tireless efforts on his behalf. Paul Durand-Ruel, who had inherited a gallery from his father, was the Impressionists' most important dealer—right from the start they had a home in his gallery in Rue Lafitte, which opened in 1870.

During the Franco-Prussian War, he used Monet's stay in London as an opportunity to launch the artist—in whose abilities he had boundless confidence—in the art trade there, opening a gallery in New Bond Street. In 1872, he sold more than twenty-three paintings by Monet. Quite often, Monet's sole income came from the sales of this sympathetic gallery owner.

The second Impressionist exhibition took place in 1876 on the premises of the recently opened gallery of Durand-Ruel in Rue Le Peletier, off Boulevard Haussman. Although Monet had entrusted some pictures to one of Durand-Ruel's keenest competitor, Georges Petit, who ran a successful gallery together with Italian dealer Giuseppe de Nittis, Durand-Ruel remained the Impressionists' most important dealer, working hard for them right into the 1880s. His decision to open a gallery in New York showed remarkable foresight, for ultimately it opened the door to the lucrative American art market for the Impressionists.

In 1895, Monet exhibited more than fifty paintings at Durand-Ruel's Gallery in Paris, including many of his cathedral pictures. His friend, the journalist and politician (and subsequent prime minister) Georges Clemenceau, successfully pressed for the whole series to be bought by the French State.

Among other dealers and gallery owners with whom Monet maintained more or less close contact, we should also mention Theo van Gogh, the brother of Vincent. As an employee of the Galerie Boussod, Theo van Gogh enabled Monet to exhibit at the Royal Society of British Artists in London.

Photography and Impressionism

For his view of the Boulevard des Capucines, Monet selected an unusual vantage point—a window in the former studio of the photographer Nadar, high above the street; it was on these same premises the first Impressionist exhibition took place. Gaspar–Felix Tournachon,

professionally called Nadar, was one of the most celebrated photographers of his day. He had a reputation for portraits, but also for striking views of Paris that were often characterized by unusual points of view; some of the most striking were aerial views taken from a hot-air balloon. They were not without effect, even among artists, and some of the most interesting responses to his photographs include Monet's views of Paris. He was clearly inspired by the photographer's desire to avoid typical views by seeking out new perspectives. When Monet painted the Boulevard des Capucines from an upper-story window, he found quite a different view of the urban scene, a new, stimulating perspective on what was happening on the street. Two paintings showing Paris as a sea of banners during the closing ceremonies of the World Fair in 1878 are likewise seen from an unusual angle. In order to be able to depict the festive throng and busy mêlée on the street, Monet took up a position on a balcony and again looked down on events, inviting the viewer to look with him. Thanks to this artistic strategy, viewers can fully immerse themselves in the mood of the moment.

Also possibly based on photographic antecedents are some of the painter's early works, including *Women in the Garden*. Monet was certainly not the only painter of his day to get to grips with photography. Degas took a keen interest in the new medium, his innovative studies of the human figure (including his famous ballet dancers and music hall singers) owing much the novel angles and cropping of photography.

The great series

On the 23 March 1903, Monet wrote to his dealer Durand-Ruel: "I cannot send you a single one of the London pictures, because for this kind of work it is essential that I am able to see them all, and because, to be frank, none of them is completely ready. I'm working on them all, or anyway on a number of them, and I don't yet know how many I will be able to exhibit, for what I have undertaken is very tricky." Monet had in fact already returned to Giverny, but regarded the pictures painted in England as still unfinished.

Statements of this kind by the artist are instructive for the light they shed on the genesis of many of the works from his late period. His tireless struggle with the fugitive nature of reality and with the variability of perception prompted him to begin several works at the same time. He was thus able to paint a series of views showing the same subject in different atmospheric conditions and at different times of the day. Every series is thus an indissoluble whole. So it is no accident that, though Monet let the paintings of Rouen Cathedral be exhibited, he did not allow Durand-Ruel to sell them individually. In his forlorn attempts to capture the constant changes in nature (an ambition he himself described as impossible), the artist worked on a picture only until the atmospheric conditions changed. Then he immediately began another version. As Monet explained, he found himself forced to keep "over fifteen paintings going at once, stopping and resuming work on them again, without thereby ever being able to capture the precise moment." As he added: "I had up to twenty sessions on paintings that I ruined every time, and ended up doing just a sketch in two minutes."

The Hoschedé Family

In 1875, Ernest Hoschedé, a prosperous businessman and passionate art collector who had already bought some of Monet's works, invited the artist to stay at his château, Rottembourg at Montgeron. The estate belonged to the family of his young Belgian wife, Alice Raingo. Hoschedé was one of the most important patrons of Impressionism, at least until 1878, when the unfortunate merchant went

bankrupt and was forced to sell large parts of his private collection of paintings, including sixteen paintings by Monet, five by Manet, thirteen by Alfred Sisley, and nine by Camille Pissarro. The amounts raised by the sale were disastrously low. Monet's pictures fetched on average only 150 francs each. "The sale of the Hoschedé collection will kill me," commented an embittered Pissarro: "Now I haven't got a sou in my pocket."

To add to the financial disaster, Hoschedé also had an emotional catastrophe to endure: his wife had fallen in love with Monet and had embarked on an affair with him. Admittedly, the situation seems not to have been altogether intolerable, since the two families lived together in Vétheuil. Alice took care of Camille, the painter's severely ill wife (who died in September 1879), meantime wholly respecting the feelings that Monet had for his wife. Ernest soon moved back to Paris, where he tried desperately (and unsuccessfully) to improve his financial situation. Alice remained in Vétheuil with her six children, Monet, and his two children. From then on, Alice was the painter's loyal helper. In 1881, the two decided to make their relationship public and moved to Poissy. After Ernest died in 1892, they were finally able to marry. The result was a lively, thoroughly modern patchwork family with lots of children. Alice's daughter Blanche later married Monet's eldest son Jean, so that she was from then on at once Monet's stepdaughter and daughter-in-law.

A divisive novel

In 1886, Émile Zola published the latest volume in his *Rougon Macquart* series, called *L'Œuvre*. Its hero, painter Claude de Lantier, hangs himself after the promised success he craves eludes him. The plot is rich in allusions to the contemporary art world, and the references to Impressionists are in places so obvious that there is hardly any doubt who is meant. Particularly in the situation of his unfortunate hero, Zola seems to have taken three artists he knew well as his sources—Manet, Monet, and Paul Cézanne. Cézanne was furious when he read the novel, which he saw as a betrayal by his long-standing friend Zola. Monet, in contrast, wrote a letter to Zola on 5 April 1886 in a firm, calm tone. "You were kind enough to send me *L'Œuvre*," he wrote, "and I am most grateful to you. It is always a great pleasure for me to read your books, and this one interested me particularly because it is about artistic matters we have been struggling with for a long time. I've almost finished it, and to be frank, it has upset and worried me. You have consciously tried to avoid any of your characters being like any one of us; yet all the same I fear our enemies in the press and the general public will bandy about the name of Manet, or at least our names, and equate them with failure, which I assume was not your intention. I'm sorry to say this. It is not criticism. I read *L'Œuvre* with great pleasure, and every page recalled some fond memories." Despite the measured tone of his response, the incident put an end to a friendship with an ally who for many long years had championed the ideals of the Impressionists.

The Caillebotte bequest

"I wish funds to be taken from my estate such as are necessary to organize an exhibition of the group called Les Intransigeants or Impressionists in 1878 in the best possible circumstances. It is not easy for me to estimate here and now how much will be necessary for that. It will possibly amount to 30,000–40,000 francs or more. The painters represented in the exhibition are Degas, Monet, Pissarro, Renoir, Cézanne, Sisley, Berthe Morisot. I mention these artists without excluding others." These words are the opening lines of a will that artist and collector Gus-

tave Caillebotte drew up in 1876 when he was only twenty-seven. He was much preoccupied with the thought of his own death, and was worried about the future of his dearest friends and colleagues. He appointed Auguste Renoir his executor.

The painter's will also provided that his own extensive collection of paintings should pass into the possession of the French State. When he died in 1894, this bequest, which included numerous paintings by Monet, caused a bitter controversy in the art world. When they learnt of the new acquisitions, professors of the École des Beaux-Arts threatened to resign, and it took two years for the authorities to extricate themselves from an embarrassing situation. Some of the sixty-seven paintings from the painter's estate were finally rejected, on the basis of reports by a "committee of experts" whose duty it was to determine the "true artistic value" of the paintings. Among the works rejected were, along with those of Manet, Sisley, Renoir, and Pissarro, paintings by Monet.

The works accepted for the state art collections were considered good enough to be exhibited in the rooms of the Palais de Luxembourg, the new museum for contemporary art in Paris. But they were all shown together in a specially constructed wing alongside the museum. Even on the threshold to the 20th century, Impressionism still evoked violent opposition from artists and academics.

Monet's water garden

In the spring of 1883, Monet moved into a property in Giverny that he rented from a Monsieur Singeot, and in 1890 he was able to buy it. The house was a typical Norman *clos*, or country house. It was surrounded by a small garden and was adjacent to a railroad line; the tracks were among the most difficult obstacles Monet had to overcome in laying out his famous garden. With the energetic support of Gustave Caillebotte and Octave Mirbeau, both of them keen gardeners, Monet set about laying out the terrain around the house. The works he put in hand at any one time depended on the funds he had available. Not surprisingly, the most expensive features date from the time when the artist had already consolidated his financial position.

He also had to contend with bureaucratic obstacles before he received permission to convert the land he had bought opposite his house in Giverny into a garden the way he wanted it. He had to divert the little Epte River, which passed by on the other side, around the water-lily pond, which he later immortalized in numerous paintings. The inhabitants of Giverny, however, were afraid that damming the Epte could endanger their water supply. Nevertheless, Monet set about the project with great determination. He had never been so close to realizing his dream of a water garden.

In a letter dated 17 July 1893, he set out his intentions to the prefect of the Eure *département*, trying to dispel the latter's concerns: "I should of course inform you that this water-plant feature does not have the meaning the term might suggest, and that it is not a matter here of mere decoration to please the eye, but also of a collection of subjects for my paintings as well; and finally, I can assure you that I am planting solely plants such as water lilies, reeds, irises and various other species that are also found in the wild in our waterways." After he had initially set up a studio in an existing outbuilding, in 1899 he had a large, light studio built opposite the greenhouses. This was where he would paint the large series of water-lily pictures now exhibited in the Orangerie.

Japanese art and Impressionism

Monet first began collecting Japanese prints in 1871, although he may have owned individual works in earlier

years—for example the print by Hokusai that provided inspiration for the *Terrace at Sainte-Adresse*, which he painted in 1867.

The works in his collection reflect a taste in art that was at its peak at the time. Monet loved the Japanese artists who were particularly in fashion in his day—Utamaro, Hiroshige, and Hokusai—but also bought works by Toyokuni, Kiyonaga, Shunsho, and Sharaku. These Oriental prints chiefly adorned the walls of the dining room, the studio, and the small reading room in Giverny, but there were occasional examples of Japanese art in other rooms of the house as well. According to statements by contemporaries who visited him at home, Monet loved looking at the atmospheric Far Eastern landscapes over lunch.

Among the Japanese prints Monet owned—they can still be seen in Monet's house in Giverny, which following restoration is once again open to the public—there are several masterpieces by Utamaro. They include a young woman combing her hair, meantime absentmindedly feeding her son; a mother watching her child play; and a splendid branch with two birds—a scene which in its delicacy and linearity calls to mind the views that Monet himself painted of his pond during those years. There are also some very famous works by Hokusai and Hiroshige, for example the latter's scene of a bridge in a downpour, which Van Gogh had already used as a model (*Bridge in Rain*, 1887, Van Gogh Museum, Amsterdam). Monet also drew directly on examples in Japanese woodcuts when designing the bridge over his water-lily pond.

Monet's art collection

Although he managed to stabilize his financial position only at an advanced age, even when he was young Monet liked to surround himself with the works of painters he admired. They were above all paintings by his fellow Impressionist that he had acquired over the years. He took many of these works with him to Giverny. The walls of his house there were graced by masterpieces now found in collections in the most important museums in the world.

"I was looking forward to being able to admire a whole collection of Monet's paintings," Ambroise Vollard reported after visiting Giverny, "but in fact I got to see only a few of them. The house was very large, but the walls disappeared behind pictures by his colleagues. It became obvious to me that you don't get to see so many rare works just like that, even with the most famous collectors."

Monet enjoyed showing friends his own collection. It was a snapshot of the history of a broad movement in French art. He owned twelve paintings by Cézanne, the controversial painter from Aix-en-Provence who was so close to the Impressionists personally and yet so far from them in style, two by Degas, a Henri Fantin-Latour, a Caillebotte, five pictures by Berthe Morisot, and a large number by Pissarro. He also owned a number of paintings by his friend Renoir that were particularly associated with his youth, for example Renoir's portrait *Camille Monet Reading Le Figaro*, and a number of later works.

There was also a tribute to his teachers: Manet—the admired "father of modern painting"—was represented by eight paintings; Delacroix, over whose shoulder the very young Monet had covertly glanced to try to understand the secrets of his techniques, by three works; Johann Barthold Jongkind, one of his earliest "teachers," by four. Monet's collection was also remarkable for its glimpses of modernism, represented by one Signac, an Édouard Vuillard, and two bronzes by Auguste Rodin. In a book published in 1948, the publisher Thadée Natanson recalled that Monet was happy to have these paintings around him. "Visitors allowed into this room would see him standing immobile in front of a Delacroix or Cézanne, mutely drawing

attention to a picture with a gesture of his hand or chin, or saw him smiling in front of a Renoir."

Proust and Monet's garden

"Poppies, scented sweet peas, white and yellow prickly poppies, blue sage, blue water lilies in the pool, dahlias, irises, golden larch, lilies, Japanese peonies, short-stemmed roses, small-leaved watercress, in the greenhouses sinningia and orchids, clematis and rose tendrils on wires, wickerwork, sunflowers in large clumps, chrysanthemums, apple trees, poplars, willows, including many weeping willows and wisteria," runs a description of the plants in Monet's garden in Giverny. A lover of plants and flowers, Monet took gardening and botanical matters very seriously. Every individual flower, every color, every combination in Monet's garden was the outcome of careful, refined deliberation. Monet had regarded nature from the first as his loftiest object of study. He opted for open-air painting from inclination, and preferred working close to nature to working within the four walls of a studio.

In Giverny, this idea had become a reality in the exuberant area of the garden that Monet laid out for himself, in order to develop his palette, but even more as balm for his increasingly tired eyes. Right until the very end, he was still checking whether the flower bulbs he had ordered from Japan had arrived. When he asked, he was already aware that he would not see them blossom. "You'll see them," he said to his friend Clemenceau, who stood by him in his final days. The lily bulbs did not arrive in time.

The affinity between Monet's paintings and Proust's writings is unmistakable. The style of painter Elstir, a figure in Proust's masterpiece *Remembrance of Things Past*, is reminiscent in many respects of that of the great Impressionist. Proust for example mentions the power of the artist "to render things not as he knows they are but according to the optical illusions of which our first visual impressions consists"—an apt description of the artistic experiments of the late Monet.

In one passage from this novel, Proust describes among other things a landscape that is very similar to the garden Monet created in Giverny—a place that the writer mentions several times, even if he had not seen it with his own eyes. He was nonetheless in a position to imagine it:

"Here and there on the surface, blushing like a strawberry, floated a water lily flower with a scarlet heart and white fringes. Farther on, the flowers were more plentiful, paler, less glossy, more abundantly seeded, more tightly folded, and more disposed, by chance, in festoons so graceful that one would imagine one saw floating upon the stream, as after the sad dispersal of a *fête galante* by Watteau, moss roses in loosened garlands. In another spot, a nook seemed reserved for lesser species, which had the clean white and pink of summer stock, freshly washed like porcelain looked after by a meticulous housewife, whereas farther on, others, pressed close together like a floating flowerbed on the deceptively transparent surface of the water, suggested garden pansies that, having settled like butterflies, were fluttering their blue and burnished wings over the transparent depths of this watery garden. A celestial garden, moreover, for it gave the flowers a soil of a color more precious, more moving, than their own, and, whether sparkling beneath the water lilies in the afternoon in a kaleidoscope of silent, watchful and mobile contentment, or glowing, towards evening, like some distant harbor, with the rosy dreaminess of the setting sun, ceaselessly changing yet always in harmony, around the less mutable colors of the flowers themselves, with all that is most profound, most evanescent, most mysterious— all that is infinite—in the passing hour, it seemed to have made them flower in the sky itself."

Advice for young artists

One of the reasons why Monet, on his own admission, did not take part in the final Impressionist exhibition in 1886 was the participation of two artists who had been invited on Pissarro's recommendation—Signac and Seurat. Monet regarded these young artists with a certain suspicion. With Pointillism, they had introduced a new technique that was to some extent a scientific reworking of Impressionism, whose first exponent Monet had been. The mistrust Monet felt for these artists is reminiscent of the reservations Manet had once felt for the newly arrived young artist from Le Havre, and in general for the "*little painters*" band of landscape artists led by Monet.

Even artists who in their time are the most innovative and revolutionary can later have trouble accepting the style of a new generation. And just as Monet had admired Manet, so Signac and Seurat venerated, for comprehensible reasons, the aging Impressionist in Giverny.

In 1912, Signac wrote to Monet, whom he addressed as *Maître*, that he had experienced a powerful and perfect emotion standing in front of pictures so familiar to him, such as Monet's views of Venice, similar to what he had felt in 1879 in front of the rail station pictures, which had "set their stamp on my artistic development." In his despair at the hostile attitude shown by the Impressionists apart from Pissarro, Signac tried to placate them. So he wrote a beseeching letter to Monet, asking for his understanding: "I will describe my position to you quite frankly. I have been painting for two years, and during that time have had no other model but your works. I went down the unusual path you opened up. I always work conscientiously and steadily, but without receiving help or advice, because I know of no Impressionist painter who could have guided me, and I live in an environment that rejects what I do. I'm afraid to stray from my path, and am therefore asking for permission to meet you, even if just for a short visit. I would be more than happy to be allowed to show you five or six of my studies. Perhaps you will tell me what you think of them and give me the advice I, who am exposed to the most violent doubts, so urgently need, since I have always worked alone and without a teacher, without correction or criticism."

How Monet answered his young colleague is not known, though we can well imagine that the artist reconsidered his prejudice against the Pointillists, for there is a work by Signac among the paintings in his collection at Giverny.

But Monet never liked giving advice. Anyone who asked him how to proceed was supposed to have been told: "I advise you to paint as well and as much as you can, without worrying about whether you are painting ugly pictures ... If your painting doesn't then get better of its own accord ... there is nothing to be done ... nor can I do anything about it."

Anthology

I must confess that the painting that held my attention longest was *Camille [in a Green Dress]* by Monsieur Monet. That was a lively, energetic canvas. I had just finished wandering through the cold, empty rooms, disappointed at not finding any new talent, when I saw this young woman, with her long dress trailing out behind her ... You can't imagine how good a bit of admiration feels when you are tired of laughing and shrugging. I don't know Monsieur Monet, I don't even think that I have ever previously paid any attention to one of his paintings. And yet I felt as if I were an old friend, because this picture of his tells a whole story full of élan and truth. ... It is no longer a realist we are dealing with here but a subtle, strong interpreter who is in a position to render each detail without being pedantic.

Émile Zola
"Mon Salon," in: L'Évenement, 19 April 1866

If you want to sum them up with an apt expression, you have to coin a new term –Impressionists. They are "impressionists" in the sense that they don't portray a landscape but the sensation evoked by the landscape. The very word has entered their language: not *landscape* but *impression*, in the title given in the catalogue for Monsieur Monet's *Sunrise*. To this extent, they abandon reality for the realm of pure idealism.

Thus, the essential difference between them and their predecessors is a question of more and of less in the finished work. The object to be represented is the same, but the means by which it is translated is modified, debased, some would say.

Such is the endeavor, the whole endeavor, of the Impressionists.

Jules Castagnary
"Exposition du Boulevard des Capucines – Les Impressionistes," in: Le Siècle, 29 April 1874

Monsieur Claude Monet is the most notable personality in this group. This year, he exhibited wonderful station interiors. You can really hear the trains rumbling in, you see billowing clouds of smoke drifting up to the roof of the vast halls. ... Our painters have to experience the poetic in stations just as their fathers found it in woods and riverbanks.

Émile Zola
In: Le Semaphore de Marseille, 19 April 1877

The Impressionist sits on the bank of a river. The water takes on every possible hue according to the state of the sky, the perspective, the time of day, and the calmness or agitation of the air. Without hesitation he paints water which contains every hue. The sky is overcast and it is rainy; he paints water that is glaucous, thick, opaque. The sky is clear the sun is bright; he paints the reflections seen in the agitated water. The sun sets and casts its rays on the water; to depict these effects, the Impressionist covers his canvas with yellows and reds. And so the public begins to giggle.

Winter is here. The Impressionist paints snow. He sees that, in the sunlight, the shadows on the snow are blue. Without hesitation, he paints blue shadows. So the public roars with laughter.

Théodore Duret
Les Impressionnistes, 1878

His ice floes beneath a flushed sky are of intense melancholy, his sea studies with the waves breaking on the cliffs are the most lifelike seascapes I know. And beside these paintings, there are landscapes, views of Vétheuil, a field of poppies of wonderful color aflame under a pale sky. The artist whose brush shaped these works is unquestionably a great landscape artist, whose eye ... captures all the phenomena of light with startling fidelity. How real the spray of his waves whipped by a ray of light; how his rivers flow, speckled by the teeming colors of the things they reflect; how the light, cold gusts rise from the water in his paintings, into the leavers and through the blades of the grass! ...

It is with joy that I can now praise Monsieur Monet, for it is mainly due to his works and those of fellow Impressionist landscape painters that the art of painting has been redeemed. ... Pissarro and Monet finally emerged victorious from a terrible struggle. We may say that the great difficulties that light throws up for painting are finally solved in their paintings.

Joris-Karl Huysmans
L'Art Moderne, 1882

Last year, I often accompanied Claude Monet in this area in his search for impressions. He is actually less a painter now than a hunter. He went on ahead, followed by children who carried his canvases, five or six canvases in which the same subject was depicted at different times of day and with different effects.

He took each of them in turn, and put them aside again, depending on how the sky changed. And the painter waited in front of his subject, watched the light and shadow, captured a ray of light or a passing cloud with a few brushstrokes and put them down quickly on the canvas, meantime despising anything false or merely conventional.

I've seen him capturing light glittering on a white cliff, recording it in a stream of yellow tones that strangely enough captured the surprising and fleeting effect of this intangible and dazzling glistening. Another time, he seized a shower of rain passing over the sea with his bare hands and threw it on the canvas. And what he painted in this way really was rain, nothing but actual rain.

Guy de Maupassant
"La Vie d'un Paysagiste," in Gil Blas, 28 September 1886

Whether he spreads before us a meadow reddened with flowers, a field of light oats; whether he frames a lump of earth, this massive hilltop; whether he presents these figures of airy, rhythmic girls, rising willowy in the golden sunshine and the passing clouds—he is always the incomparable painter of earth and sky, preoccupied with fleeting light conditions on the permanent background of the universe. He conveys the sensation of the ephemeral instant that comes into existence and then departs and never returns, and at the same time he constantly evokes in each of his canvases—through the weight, the power that comes out from within the curve of the horizon, the roundness of the terrestrial globe—the course of the earth through space. He unmasks changing portraits, the faces of the landscape, the manifestations of joy and despair, of mystery and fate so that we invest everything around us with our own image. He anxiously observes the differences that occur from minute to minute, and he is an artist who sums up meteors and elements in a synthesis. He tells tales of mornings, noondays, evenings; of rain, snow, cold, and sunshine. ... He is a subtle, strong, instinctive, varied painter, and a great pantheistic poet.

Gustave Geffroy
Preface to a catalogue for an exhibition, 9 May 1891

You can follow Monet where you like, to Italy, Provence, the valleys of Vernon, or the cliffs of Étretat or Belle-Île, the green, gleaming sea off Antibes or the gorges near Fresselines, the tulip-studded expanses of Holland—for all the variety of these landscapes, he always orientates himself to the same thought: the individual character of a landscape, the seascape, a cliff, a flower, a figure in its very special lighting, its momentariness, the minutes during which your eye falls on it and takes in its harmony.

Octave Mirbeau
"Claude Monet," in: L'Art dans les Deux Mondes, 7 March 1891

Cézanne's statement that 'Monet is all eye … but what an eye!' describes with great clarity the painter's role in the history of taste, but does not do sufficient justice to his art. … Monet was undoubtedly an inspired renewer of seeing. He saw aspects in the relationship of light and colors that no one before him had ever seen.
Thanks to his concentration on light and color, he found the most appropriate form of expression for his artistic values. He abstracted them from other aspects of his painting, thereby enhancing their effect.
Not content with that, since he was painting with the firm intention of focusing solely on rendering light and color, he arbitrarily eliminated, almost without being aware of it, all literary and social aspects, even more radically than Manet had done.
He achieved therewith such a high degree of artistic autonomy that from then on painting as a whole moved towards the same goal.

Lionello Venturi
Les archives de l'Impressionisme, 1939

Monet proceeded as if he had nothing to lose, and in the end proved to be as 'experimental' as Cézanne. That he lacked capacity for self-criticism was to his advantage in the long run. … If Monet was the one who drew the most radical conclusions from the premises of Impressionism, it was not with truly doctrinaire intent. Impressionism was, and expressed, his personal, innermost experience … The quasi-scientific aim he set himself in the 1890s—to record the effects of light on the same motif at different times of the day and in different weather—may have involved a misconception of the ends of art, but it was more fundamentally part of an effort—compelled by both his own experience and his own temperament—to find a principle of consistency for pictorial art elsewhere than in the precedent of the past. Monet could not bring himself to believe in the Old Masters as Cézanne and Renoir did—or rather, he could not profit by his belief in them. In the end he found what he was looking for, which was not so much a new principle as a more comprehensive one: and it lay not in Nature, but in the essence of art itself, in its 'abstractness.' That he himself could not consciously recognize or accept 'abstractness'—the quality of the medium alone—as a principle of consistency makes no difference: it is there, plain to see in the paintings of his old age.

Clement Greenberg
"Claude Monet: The Later Monet," 1957

Monet, too, had something of the fire of Zola, but was apparently unwilling to put himself forward. The almost brutal refusal to compromise which he had shown in his youth seems to have worn off with the years so full of bitter trials. Not that his views had changed or his self-confidence vanished, but he now was somehow less eager to manifest his robust pride. He who had been the leader of the little group of his friends thus became an unobtrusive guest

at the Café Guerbois, more concerned with listening to the others than with contributing to the discussions. Having left school early, as had Renoir, he may have felt a certain lack of education that prevented his entering into the debates, just as his ignorance of the masters of the past deprived him of arguments in controversies for and against traditions. Yet his incomplete education does not appear to have elicited in him any regret; instead, he relied with superb confidence on his instincts. After all, it mattered little whether he won an argument or surprised others by a witty remark. When he put up his easel somewhere in the open, no erudition, no cleverness would help him solve problems. The only experience he cared for was that which was gained through work: the perfect blending of his energetic temperament and the delicacy of his visual sensations, the complete command of his means of expression.

John Rewald
The History of Impressionism, 1970

Monet's creative span as a painter covered more than six decades, from the early 1860s until his death in 1926. This longevity itself is remarkable in the history of art, and bears comparison with that of other titanic figures such as Titian and Picasso. Monet's range of subjects may not have been as wide as the Venetian's, and his preference for oil on canvas as an expressive medium denied him the extensive range of materials that Picasso used. But among the almost two thousand paintings that survive from Monet's prodigious output, we find a most striking variety. There are the ambitious early figure paintings—grand compositions intended to impress the public at the Paris Salon— modest still lifes, perceptive portraits, rooms grandly decorated with panels of water-lily ponds, and above all landscapes, of all kinds: highly resolved and rhythmic se-

ries, cityscapes, storm-tossed marines, tranquil pastures, rapid sketches, pretty tondos, extreme weather conditions, boating scenes, and nature marked by modernisation or pulsing with light and life. It is this extraordinary, almost unequalled, range as a painter of landscape that won Monet the international reputation that developed in the last forty years of his career, and the global fame that his works enjoy over three-quarters of a century after his death. For in Monet's lifetime the benefits of progress were frequently tempered with a sense of loss, as they are in our own day. That uncomfortable tension in the modern condition enhances the appeal of art based on nature's verities, as Monet's work so evidently is. ... Undoubtedly Monet's painting has great resonance for the contemporary audience.

Richard Thomson
In: Monet: The Seine and The Sea 1978–1883, 2003

Locations

AUSTRIA
Vienna
Österreichische Galerie Belvedere
 Garden Path in Giverny, 1902

BRITAIN
London
National Gallery
 *The Thames and Houses of
 Parliament (Westminster Bridge)*,
 1871
 Madame Monet with Her Son, 1875
 Lavacourt in Winter, 1881
Courtauld Institute of Art Gallery
 Antibes, 1888
Tate Britain
 Poplars on the Epte, 1891

CANADA
Ottawa
National Gallery of Canada
 Waterloo Bridge, Sun in Mist,
 1902–1904

FRANCE
Paris
Musée de l'Orangerie
 Weeping Willows, Morning,
 1914–1926
 Water Lilies, Morning, 1914–1926
Musée d'Orsay
 Farmstead in Normandy, c. 1863
 Déjeuner sur l'Herbe, 1865–1866

Women in the Garden, 1866–1867
Garden in Sainte-Adresse, 1867
Madame Gaudibert, 1868
The Magpie, 1869
View of Zaandam, 1871
Regatta at Argenteuil, 1872
The Pool in Argenteuil, 1872
Poppies at Argenteuil, 1873
Railroad Bridge at Argenteuil,
1873–1874
*Lunch in Monet's Garden in
Argenteuil*, 1873–1874
Corner of the House in Argenteuil,
1875
Gare Saint-Lazare, 1877
*Rue Montorgueil in Paris, During the
Celebrations on 30 June 1878*, 1878
Camille on Her Deathbed, 1879
Lady with Parasol, Facing Right,
1886
Boat in Giverny, c. 1887
Haystacks, Late Summer in Giverny,
1891
Poplars in the Wind, 1891
Rouen Cathedral in Gray Weather,
1892 (but dated 1894)
Rouen Cathedral, Morning, 1893
(but dated 1894)
Water-Lily Pond, Harmony in Green,
1899
Water-Lily Pond, Harmony in Pink,
1900
Houses of Parliament, London, 1904
Water Lilies in the Morning,
1914–1926
Water Lilies, Blue, 1916–1919
Self-Portrait, 1917

Musée Marmottan
 Sunrise, Impression, 1872
 *The Pont de l'Europe at the Gare
 Saint-Lazare*, 1877
 *The Japanese Bridge in Giverny,
 Version II*, 1918–1924
Le Havre
Musée des Beaux-Arts André
 Malraux
 The Customs House in Varengeville,
 1896–1897
Lyons
Musée des Beaux-Arts
 Storm over Étretat, 1883
Rouen
Musée des Beaux-Arts
 *Rue Montorgueil Decorated with
 Flags*, 1878

GERMANY
Bremen
Kunsthalle
 Camille in a Green Dress, 1866
Frankfurt
Städelsches Kunstinstitut
 Lunch, 1868

ITALY
Rome
Galleria Nazionale d'Arte Moderna
 Water Lilies, Pink, 1898

JAPAN
Tokyo
Bridgestone Museum of Art
The Church of San Giorgio Maggiore,
1908

PORTUGAL
Lisbon
Museu Gulbenkian
Ice Floes at Lavacourt, 1880

RUSSIA
Moscow
Pushkin Museum
Boulevard des Capucines, 1873
*The Stacks at Port-Coton (The
Rocks of Belle-Île-en-Mer)*, 1886
Rouen Cathedral at Sunset, 1894
Water Lilies, Harmony in White,
1899
View of Vétheuil, 1901
St. Petersburg
Hermitage
Woman in the Garden, 1867
*Rosebushes in the Hoschedé Family
Garden in Montgeron*, c. 1876
Pond in Montgeron, 1876–1877
Poppy Field, 1890
Waterloo Bridge, 1903

SWITZERLAND
Zurich
Kunsthaus
Water Lilies, c. 1910–1915

SPAIN
Madrid
Museo Thyssen-Bornemisza
Ebb Tide at Varengeville, c. 1882
House between Roses, 1925

USA
Boston
Museum of Fine Arts
*Madame Monet in Japanese
Costume*, 1876
*The Grand Canal and La Salute
Church*, 1908
Cambridge (Mass.)
Fogg Art Museum
Cliffs at Étretat, 1868–1869
Chicago
Art Institute
Beach in Sainte-Adresse, 1867
On the Banks of the Seine, 1868
Gare Saint-Lazare, 1876–1877
Bordighera, 1884
Boats on the Shore at Étretat, 1885
Cleveland
Museum of Art
Spring Flowers, 1864
Houston
Museum of Fine Arts
Water Lilies, 1907

Kansas City
Nelson Atkins Museum of Art
Boulevard des Capucines, 1873
New York
Brooklyn Museum of Art
The Doge's Palace, 1908
Metropolitan Museum of Art
The Green Wave, 1865
*The Bodmer Oak in the Forest of
Fontainebleau*, 1865
Terrace at Sainte-Adresse, 1867
La Grenouillère, 1869
Parisians in Parc Monceau, 1878
Still Life with Vines and Apples,
1880
Vase with Sunflowers, 1881
Chrysanthemums, 1882
Poplars, 1891
Path on Saint-Martin Island, 1908
Philadelphia
Museum of Art
Poplars, 1891
Toledo
Museum of Art
Antibes Seen from La Salis, 1888
Washington
National Gallery of Art
Bazille and Camille, 1865
Boats in the Seine near Rouen,
1872
Argenteuil, 1872
Lady with Parasol and Child, 1875
Bridge in Argenteuil on a Gray Day,
1876
The Artist's Garden in Vétheuil, 1880
Japanese Footbridge, 1899

Chronology

The following is a brief overview of the main events in the artist's life, plus the main historical events in his day (*in italic*)

1840
14 November: Oscar-Claude Monet born in Paris.

1845
The Monet family leaves Paris for Le Havre.

1846
Charles Baudelaire publishes his review of the Salon of 1846.

1855
World Fair in Paris. Gustave Courbet paints The Artist's Studio.

1856
After studying with Jacques-François Ochard, Monet meets Eugène Boudin and discovers *plein-air* landscape painting.

1857
Jean-François Millet paints The Gleaners. *Gustave Flaubert is accused of indecency in his novel* Madame Bovary.

1859
Monet goes to Paris to study painting.

1861
Begins military service in Algeria.

1862
Having returned from Algeria because of ill health, be becomes a pupil of Charles Gleyre in Paris.

1863
Salon des Refusés created, where Édouard Manet exhibits Déjeuner sur L'Herbe, *which causes uproar among the public and critics.*

1865
Monet goes painting outdoors with Auguste Renoir, Alfred Sisley, and Frédéric Bazille. *Manet consolidates his position as the leading figure in the "new painting" with another heavily criticized work,* Olympia.

1866
Monet begins work on *Women in the Garden*, his first work painted completely out of doors. Exhibits *Camille in a Green Dress* at the Salon, plus a view of Paris (Saint-Germain de l'Auxerrois). *With Camille Corot and Charles-François Daubigny in the jury, the Salon opens up to landscape painting and the new generation of artists.*

1867
Monet and Camille have their first child, Jean.

1869
He and his colleagues have severe financial problems, lacking even the money to buy paint. Paints with Renoir at La Grenouillère.
Manet and his friends meet regularly at the Café Guerbois in Batignolles.

1870
Marries Camille. *Franco-Prussian War begins.* In September, Monet leaves for England.

1871
Visits the Netherlands (Zaandam) and then settles in Argenteuil.
The Paris Commune suppressed with great loss of life.

1872
Paints *Impression, Sunrise*; gets to know Gustave Caillebotte; paints with Renoir in Argenteuil.

1873
Sets up his floating studio in Argenteuil.
Société anonyme des artistes peintres sculpteurs et graveurs founded. First Impressionist exhibition. Durand-Ruel exhibits Impressionist works in London. Prussia withdraws its troops from France.

1876
Monet begins his *Gare Saint-Lazare* series.
Second Impressionist exhibition. Renoir paints the Ball at the Moulin de la Galette.

1877
Third Impressionist exhibition. Courbet dies.

1878
Monet settles in Vétheuil. Second son Michel born. Camille falls severely ill.

1879
Monet exhibits at the Salon. Death of Camille.
Fourth Impressionist exhibition. Socialist Workers' Party of France founded.

1880

Monet decides not to take part in the Impressionist exhibition. He goes back to painting the Normandy coast. Art dealer Georges Petit buys three paintings.
Fifth Impressionist exhibition.

1881

Sixth Impressionist exhibition. Monet again refuses to take part, and enters nothing for the Salon. Moves with Alice and the children to Poissy.

1882

Exhibits with the Impressionists again. *Seventh Impressionist exhibition. Manet paints his* Bar at the Folies-Bergères.

1883

Works in Étretat. Moves from Poissy to Giverny. Travels with Renoir to Liguria and the Côte d'Azur.
Death of Manet.

1885

Paints floral decoration at the home of Durand-Ruel. Exhibits with Petit. Meets Guy de Maupassant, who declares himself an admirer of his works.

1886

Eighth and last Impressionist exhibition. Monet does not take part, but still associates with his old friends and attends their lunches at the Café Riche. Takes part in the fifth international exhibition organized by Georges Petit and the Les Vingt group exhibition in Brussels.

1888

Guy de Maupassant publishes Pierre et Jean.

1889

The *Haystacks* form Monet's first series, an approach that will characterize his late oeuvre.

1890

Vincent van Gogh commits suicide.

1892

Monet begins work on his *Rouen Cathedral* series.

1894

A bequest by Gustave Caillebotte means that some of Monet's paintings pass to the French State.
Claude Debussy, Prélude à l'après-midi d'un faune.

1895

Monet travels to Norway.

1899

Visits London, where he again paints views of the Embankment.

1907

Pablo Picasso paints Les Demoiselle d'Avignon.

1908

Monet makes a working trip to Venice.

1910

Wassily Kandinsky paints the first abstract watercolor. Henri Matisse paints La Danse.

1911

Death of Monet's second wife, Alice.

1914

Death of his first child, Jean. Begins work on the great water-lily series now exhibited at the Musée de l'Orangerie in Paris.
First World War breaks out.

1917

Piet Mondrian founds De Stijl. American Impressionist Childe Hassam paints The Avenue in the Rain.

1919

Death of Renoir. Sherwood Anderson publishes Winesburg, Ohio.
Peace conference begins at Versailles.

1922

Increasing problems with his eyesight makes further work difficult.

1923

Undergoes an eye operation.
George Gershwin, Rhapsody in Blue.

1924

Begins work again in complete seclusion.
André Breton publishes his Surrealist manifesto.

1926

(5 December) Monet dies in Giverny.

Literature

Jean Leymarie, *Impressionism*, New York 1959

John Rewald, *The History of Impressionism*, London and New York 1970

Claire Joyes, *Monet at Giverny*, London 1975

Steven Z. Levine, *Monet and His Critics*, New York 1976

Joel Isaacson, *Claude Monet: Observations and Reflections*, Oxford 1978

Charles S. Moffett and others, *Monet's Years at Giverny*, New York 1979

Anthea Callen, *Techniques of the Impressionist*, London 1982

Paul Hayes Tucker, *Monet at Argenteuil*, New Haven and London 1982

Charles F. Stuckey (ed.), *Monet 1840–1926*, New York 1985

Melissa McQuillan, *Impressionist Portraits*, London 1986

Steven Adams, *The World of the Impressionists*, London and New York 1989

Richard Kendall (ed.), *Monet by Himself*, London 1989

Paul Hayes Tucker, *Monet in the '90s: The Series Paintings*, New Haven and London 1989

Bernard Denvir, *Encyclopaedia of Impressionism*, London 1990

Bernard Denvir, *The Chronicle of Impressionism*, London 1993

Robert Herbert, *Monet on the Normandy Coast: Tourism and Painting, 1867–1886*, New Haven 1994

Paul Hayes Tucker and others, *Monet in the 20th Century*, New Haven and London, 1998

Magdalena Dabrowski, *French Landscape: The Modern Vision, 1880–1920*, New York 1999

Daniel Wildenstein, *Monet, or the Triumph of Impressionism*, Cologne 1999

Vivian Russell, *Monet's Landscapes*, London 2000

Katharine Lochnan, *Turner Whistler Monet*, London 2005

Picture credits